# PARANORMAL NEWCASTLE

## STEVE WATSON

AMBERLEY

*Dedicated to Scarlett and Faith*
*With love from Grandad*

First published 2021

Amberley Publishing
The Hill, Stroud
Gloucestershire, GL5 4EP

www.amberley-books.com

British Library Cataloguing in Publication Data.
A catalogue record for this book is available from the British Library.

ISBN 978 1 3981 0287 3 (print)
ISBN 978 1 3981 0288 0 (ebook)

Typesetting by SJmagic DESIGN SERVICES, India.
Printed in Great Britain.

# Contents

# Introduction

I love Newcastle upon Tyne. I was born here, live here and work here. I grew up in a suburb a few miles outside of the city called Cramlington and can remember my days out as a child with my Mam to 'The Toon'. We would take the bus and go to the various shops before always going to Littlewoods on Northumberland Street for our lunch. We would then return to the hustle and bustle of Eldon Square before ending the day by buying some sweets to eat on the journey home. This is how we rocked in the seventies and early eighties.

I love the history of Newcastle, which goes back in time for over 2,000 years and includes everything from a Roman occupation to a siege by the Scots. Newcastle has had its own witch trials, the Plague, a 'Great Fire' and that is all before the city centre was designed by some of the finest architects of Victorian Britain.

At one time the city was recognised as one of the most important industrial centres of the country due to its coal mines and its shipbuilding. It's where Robert Stephenson unveiled his miners' lamp before going on to change the way we travel with his railway. Joseph Swan revealed the world's first light bulb (Mosley Street was the first place in the world to be lit by electric streetlights, and the original posts are still there today).

With this history it is easy to see why 'Geordies' are proud folk, with even their name being derived from loyalty to the Crown. During the 1715 Jacobite Rebellion, the people of Newcastle were supporters of George I while most of the north supported the Jacobites – hence the term 'Geordie'. Am I proud to be a Geordie? Of course.

I also love ghosts. As a child my favourite story was that of Ichabod Crane and 'The Legend of Sleepy Hollow'. As I grew older, so did my passion for the paranormal. In a time before the Internet, I would spend hours in the local library reading ghost stories and then researching them to try and apply logic to these tales. I was fascinated by how many people were reporting seeing everything from moving objects to apparitions. People were claiming to talk to people from the past using various pieces of equipment including the infamous Ouija board.

The older I got the more intrigued I became, and in 2010 I became co-founder of a ghost hunting group called GHOSTnortheast. Over the past decade I have been lucky enough to spend many a Saturday night behind closed doors in some of Britain's most iconic and historic buildings. Nothing gives me more pleasure than investigating a building in my home town. Whether it is standing on the roof of the castle keep at midnight, going backstage of the City Hall, sitting centre stage in the empty auditorium of the Theatre Royal or visiting the basement of the Victorian Lit & Phil Library, I will never tire of the history the city.

That brings us to this book. Over the years I have been told many ghost stories of Newcastle. Some reports have been from people who have witnessed phenomena,

some have been stories that have been passed through generations and some are simply old wives' tales. The one thing they all have in common is most people are fascinated in all things ghostly.

I have included a brief history of each location to give you a background to where some of these stories could have originated. Are the ghost stories true? I'll let you decide. Either way I hope you enjoy *Paranormal Newcastle* and by the end of it you may share my passion for the paranormal or my love for the city – hopefully both!

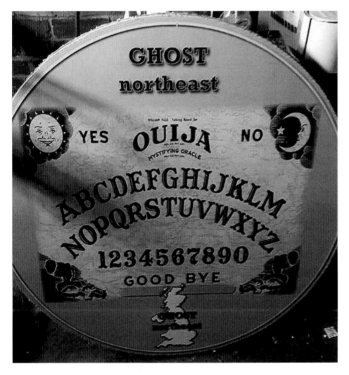

Ouija board from GHOSTnortheast, used by my group on many investigations.

# The Lit & Phil

Located at the bottom of Westgate Road between the Central station and castle keep in the centre of Newcastle upon Tyne, this glorious nineteenth-century Grade II listed building is home to the Newcastle Literary and Philosophical Society. More lovingly known as 'The Lit & Phil', this library is currently spread across three floors and houses the largest independent collection of literature and music outside of London.

The society was founded in 1793 as a conservative club where the book subjects were wide ranging, but religion and politics were prohibited. The society met up in various locations during this time, as the current building was yet to be built. It was very liberal for its day and admitted its first women members in 1804, although they still had their own reading area. In 1820, the Newcastle upon Tyne Society for Promoting the Gradual Abolition of Slavery in the British Dominions was formed within the building.

The society was also a very innovative institution, and new technologies were often displayed to its members including George Stephenson with his miner's lamp in 1815. Later, the Lit & Phil became the first public building ever to be lit by electric light when Joseph Swan arrived in 1880 with his latest invention – the light bulb.

During the nineteenth and twentieth centuries the society also branched out into music and lectures. Some notable names to speak here included Oscar Wilde and Mary Kingsley. Since 1895 the society has kept a list of its members, and it reads like a who's who of the north-east with such names as W. G. Armstrong, Thomas Bewick, Richard Grainger and Neil Tennant of the Pet Shop Boys. The society is still an active lending library and members can still enjoy the original rooms, numerous lectures and even concerts.

Looking back at the history of the Lit & Phil's location takes us to Roman times. Part of the building stands on top of Hadrian's Wall, and a small part of its stonework can still be seen in the basement area. The wall ran through Newcastle, joining at the castle keep, where it also doubled up as strong city defences. From the 1100s to the 1500s Newcastle was a city at war as the Scots constantly tried to conquer Newcastle and force the English back down south. During this time, the city walls were the main deterrent, with many deaths on either side of the wall. The site of the building at the bottom of Westgate Road also connects it to the West Road, a well-known Roman road leading in and out of the city.

During medieval times, the road led directly to the Blackgate and the castle keep. The locals would often line the street to watch the latest villain being led to the gallows or gaol. These would have included people accused of theft, and women being accused of being witches, which is well documented in Newcastle folklore. This leads us up to 1825 when the society's members decided to build themselves a home in Bolbec Gardens, which is now lovingly called the Lit & Phil.

GHOSTnortheast investigated four main areas of the library. Firstly the first floor, which is filled from floor to ceiling with books dating back to when the society began. You never forget the first time you walked into this room with its beautiful domed glass ceiling. The word breathtaking springs to mind.

The Lit & Phil is said to be home to over sixteen ghosts, ranging from a Witchfinder General to a little girl. The basement is home to stories of two ghosts. The first is that of a lady who is thought to have worked in the library many years ago. It is claimed that she moves the roller racking shelves and reports of her voice and footsteps are reported in the area.

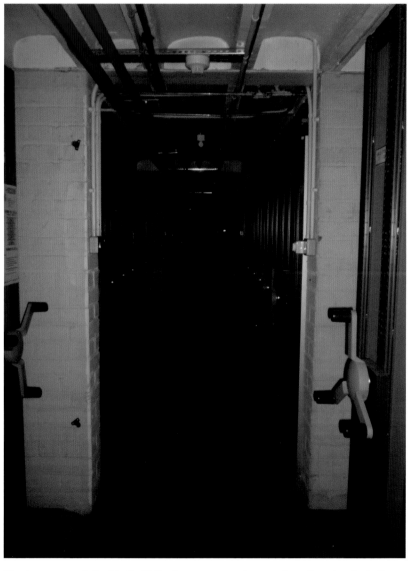

The basement of the Lit & Phil where many noises are heard, and a dark figure has been spotted many times.

The second sighting is of a man. He is said to be more aggressive than the lady, but no one is sure who he is. He is said to show himself at the end of the corridor in a hunched form and the sightings are often accompanied by very loud banging on the metalwork. There have been some very impressive photographs taken in this area.

Upstairs in the main library area there have been reports of books falling off the shelves by themselves, voices telling people to 'ssshhhhh' if they are talking too loud and strange lights at night times.

A local newspaper recorded ghost hunting members of GHOSTnortheast conducting an experiment where a specific Victorian book about witchcraft began to record an unexplained electromagnetic field. Is this linked to the reports of a dark hooded figure that has been seen wandering around the balcony overlooking the main library? Could the same figure be the Witchfinder General that visited Newcastle in the seventeenth century to send the Newcastle witches to their deaths?

*Above left*: Sir Joseph Swan, inventor of the light bulb.

*Above right*: Banging is heard from above.

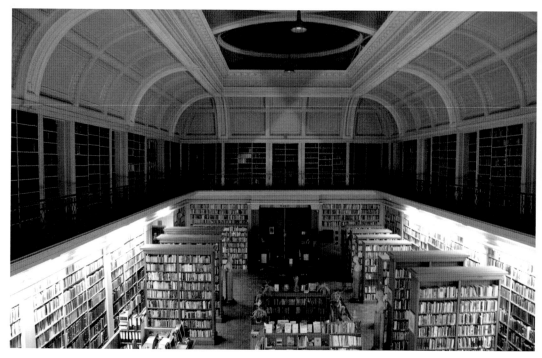

Upstairs of the Victorian library.

Rumoured to be the home of someone that has a distaste for witches.

# Tyne Theatre and Opera House

Newcastle is a city with a stunning history that can be traced back over 2,000 years. The city's castle was built on an Anglo-Saxon burial ground and Hadrian's Wall runs straight through the city centre. If you take a walk out to the west of the City near Westgate Road you will see the remains of the old city walls that guarded the people of Newcastle for over 700 years.

Westgate Road is named because it was the main entrance to the city in Roman and medieval times. The West Gate was one of the most important entrances for armies and trade to pass through. Many enemies and criminals were beheaded and their heads were put on pikes to be displayed at the West Gate as a warning to others.

Many people were buried in this area as they were buried outside the city walls in paupers' graves or because they weren't welcome in the city. In 2008, as contractors were clearing ground for construction of the buildings nearby, work had to be stopped as skeletons were found. The builders had unearthed a plague pit from the Middle Ages and Roman times.

So, as you see the area around this part of Newcastle is rife with death and murder and the soil certainly seems steeped in blood.

When we look around this area there are lots of fantastic buildings, but one stands out more than the others as it has been part of Newcastle's heritage since the nineteenth century and is renowned across the country for its beauty from both inside and out: the Tyne Theatre and Opera House. The Theatre opened on 23 September 1867. It was built by Joseph Cowen, who owned Blaydon Brickworks. Cowen employed William Parnell to design the new theatre in Newcastle and was set up to house a local theatre company.

Over the next fourteen years George Stanley managed to produce a host of plays, operas, musicals and pantomimes.

However, during the 1880s the local productions couldn't compete with the now travelling large productions from the capital and the theatre had to change to house these visitors.

Over the following thirty years, the theatre would change hands several times as various managers were brought in to continue its success and compete with the Theatre Royal on the other side of the city. Most notable of these managers was Sir Augustus Harris.

Harris had a fantastic reputation as he had successfully managed the Theatre Royal on Drury Lane in London and over time had become known as 'The Father of Modern pantomime'.

His continued success and partnership with James Howard would see the theatre grow as they added the properties around the building to expand the

prominent location. This would also see some of the biggest shows and star names of Victorian times appear on the theatre's stage.

Unfortunately, during the early part of the twentieth century, the Tyne Theatre started to take a back seat to cinema and a downturn in attendance during the First World War took its toll and in 1917 the theatre had to close its doors. It remained closed for two years before, in 1919, Sir Oswald Stoll bought the lease and converted the theatre into a cinema.

The Stoll Cinema was to thrive for the next forty years as it competed with several other cinemas within the city.

However, the building would become a victim of the publics' changing tastes again and as the swinging sixties arrived, so did television. This saw a rapid decline in ticket sales. Fighting closure, the Stoll started to show X-rated films leading to several protests from the local residents. However, this niche market was not to save the cinema. In 1974, the Stoll showed its final film and shut its doors after half of century of projecting some of Hollywood's biggest names.

With worries that the building would fall into disrepair or be demolished to make way for a modernised city centre, a protection order was placed on the building. Three years later the lease was transferred to the Tyne Theatre Trust, who were determined to bring back the glory days of this famous building. During the exploration of the building, they found that the original wooden stage machinery was perfectly intact after 110 years. It was simply still in situ behind the cinema screen that had been installed by Mr Stoll.

The need to restore this theatre, complete with its unbelievable wooden stage mechanics, immediately became clear for the public to enjoy once again. The theatre reopened and enjoyed popularity in the early eighties.

However, tragedy was to strike in 1985. On Christmas Day, only four months after the theatre celebrated being upgraded from Grade II to Grade I status, a fire broke out backstage, destroying the fly tower. In January 1986, strong winds brought down what was remaining of the wall and it collapsed onto the stage and the Victorian machinery below. Restoration work began in earnest and the theatre was reopened in November 1986 after a £1.5-million facelift. The Tyne Theatre and Opera House Preservation Trust currently owns the building and have plans for further refurbishment in the coming years.

As with any good theatre, the Tyne Theatre has a story of a resident ghost or two. The first was the story of Bob Crowther, who worked in the theatre behind the stage. In 1887, a cannonball that was used in the 'thunder run' rolled out of the track and fell onto the unfortunate Bob standing below. Bob was killed instantly. He has been spotted around the sides of the stage watching as people pass by. There have been reports of people being touched and pushed in these areas, or a cold breath near to their faces. Bob is also said to have a favourite seat in the theatre where he has often been seen. It is also reported that people have become uncomfortable in this chair for no reason.

The second resident ghost of the building is thought to be of a young actress called Bessie Featherstone. Bessie was an aspiring young actress who regularly performed in pantomime. Unknown to her, she had contracted typhoid and she collapsed and died on stage on New Year's Day in 1907 during a performance of *Aladdin*. *Aladdin* would not be performed in the theatre again for nearly a hundred years. A woman's voice

and moans have been reported on the stage many times, especially when the theatre is dark. Could this be Bessie putting on one last performance?

The building is so vast that there seems to be a story for every area. Under the stage in a vaulted area it is believed that two grave robbers were buried alive within the walls. Scratching and banging has been heard on the thick stone bricks in this area.

The fire exit from the top floor still uses the old penny entrance. This was a staircase alongside the building where the working class would pay a penny to sit 'in the Gods'. There have been many reports of figures seen in this area with a strong smell of cigarette smoke. At the bottom of the stairs there is the original cash turnstile and office.

A face has often been seen looking out of the office door window. This was photographed in 2019 and there has been much debate whether someone has captured the face of the past or a simple reflection.

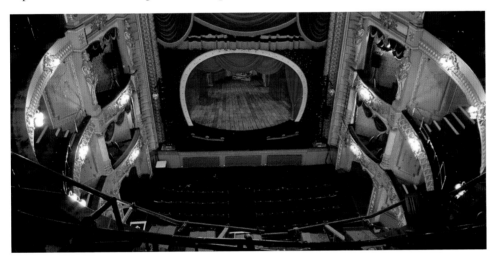

*Above*: Main auditorium of the theatre.

*Right*: Model showing the several floors of the theatre.

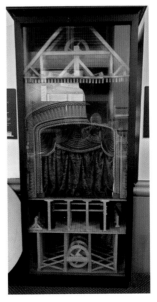

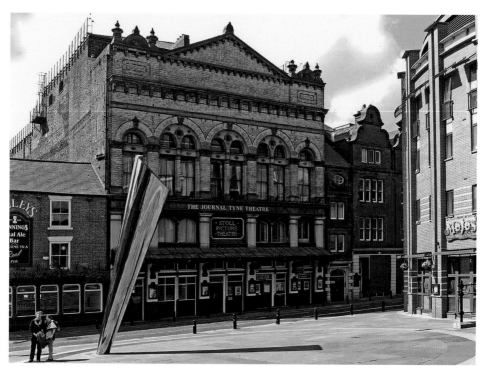

Outside of the location.

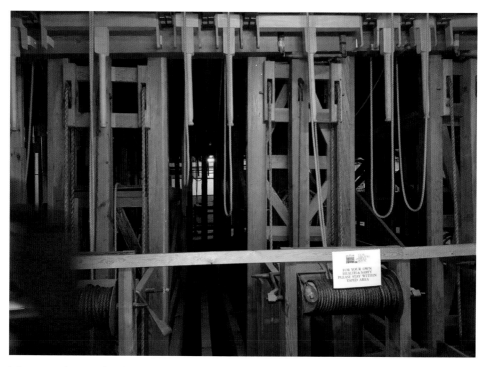

The area where Bob, the resident ghost, has been seen.

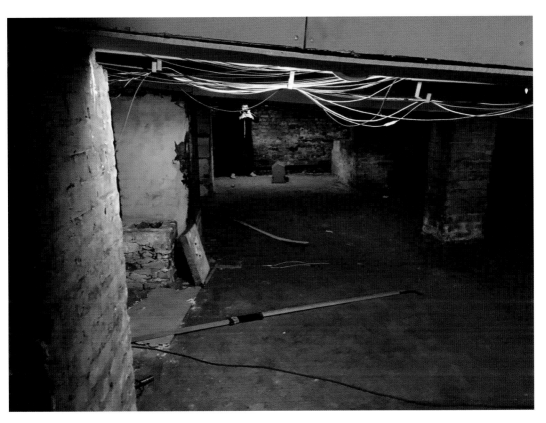

*Above and right*: The undercroft and where gravediggers are heard scraping against the stone walls.

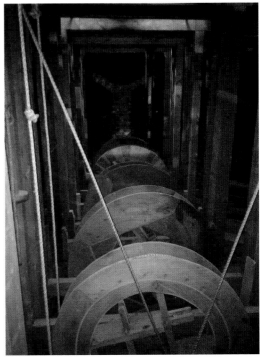

# The Black Gate

As you walk towards the Black Gate, you will cross the wooden walkway. Look down to your left and you will see the remains of the Heron Pit. The pit was a jail used in the early days of the castle keep and was feared by all criminals. It was a windowless oubliette or a hole in the ground where the most notorious criminals were thrown and left to rot for their crimes. The way in or out was a trap door above. This pit gained its name from its creator: Sheriff William Heron. Another jail called the Great Prison lies opposite, although very little of its remains can be seen today.

The Black Gate was built over a three-year period between 1247 and 1250 as a defence to the north entrance to the castle keep. Originally the building was just the archway with two side towers that would have been used as rooms for the guards who would have manned the portcullis into the Garth.

The seventeenth century would see the Black Gate go through several changes that saw it expand in both size and use. In 1618, Alexander Stephenson leased the area from James I. He added two floors to the one-storey, flat-roofed building and leased out the building as a living area. It is during this time it is believed that the Black Gate was named. Contrary to the beliefs that the name originated from its dark, bloody past, in fact it was named after one of Stephenson's first tenants, whose name was Patrick Black.

Further work can be dated to the 1630s. John Pickell, a local man, redesigned the building as he opened it as a tavern. This tavern would stay until the nineteenth century as the Black Gate environs turned into a slum area. The building became a squalid tenement and was listed in history as a 'great nuisance'.

The council of the time wanted to demolish the area as it had become a magnet to the more unsociable members of society. However, in 1856, the Society of Antiquaries of Newcastle bought the building and later in 1883 opened the building as museum. They were to own the building until 2003 when the ownership was taken over by the City Council. Today, the Black Gate you see is very much the same outside, but the interior has been redesigned and houses a museum of the Castle Garth and old Newcastle.

The Black Gate has seen hundreds of years of the bloody history of Newcastle and comes with a wealth of ghost stories attached. The story with the earliest resident is the reports of a cavalier being seen in the doorway of the archway. It is said he is lying in agony with injuries he sustained from the closing of the portcullis. The reports say that when you walk towards the figure to help, he simply disappears. Was he an invading soldier or a guard that was caught in a nasty accident? Maybe you can ask if you're walking through the archway late at night and you come across his injured body.

The wooden walkway you walked across coming to the Black Gate is said to be the home of a black shadow or hooded figure that doesn't take kindly to people disturbing him. There have been reports of people being pushed and grabbed as they walk between the pits after seeing the figure.

Screams are also heard coming from below your feet in this area. Are these the screams of the prisoners thrown into these primitive jails? Or could they be the screams of murderers and thieves that were executed on the land above?

There have been many sightings of Victorian women around the area late at night. These are ghostly white figures that are walking around the building as if it is still open for business. These figures also disappear as they walk away through the walls and closed doors. As you can see, probably not the best area for the faint-hearted to walk alone.

The entrance where a dying cavalier is seen.

*Above and opposite*: External shots of the Black Gate.

# The Castle Keep

Sitting proudly on the banks of the Tyne, overlooking the world-famous Tyne Bridge, is the building that gives Newcastle its name. The castle keep is probably one of the finest examples of Norman castle buildings still standing in Britain. The castle itself dates to 1172, but before we look at its industrious history, we need to research the land that it stands on.

A settlement on the site dates back as far as the second century when the Romans built on the land to defend their newly built Tyne Bridge, which wouldn't have been as grand as what stands now. The Romans named the area Pons Aelius and was important to Emperor Hadrian. During Anglo-Saxon times the area became known as Monkchester and the Garth area became a burial ground.

In 1080, William I commissioned a wooden motte-and-bailey castle to be built. It was replaced by Henry II in 1172, who employed the Grand Mason Maurice to build the stone building that remains today. The additional four stone towers that corner the original keep were added in the thirteenth century for added protection.

Due to the addition of strong city walls over the following years the keep fell into disrepair, with it being described as ruinous in 1589. In 1643, the then mayor, Sir John Marley, repaired the keep and brought it back to its former glory due to the ongoing English Civil War. A year later, in 1644, the keep enjoyed its biggest claim to fame as the Scots besieged Newcastle. It took them three long months to finally crack the spirit of the Geordies and take the city, including the keep.

After the border wars ended, the keep was used as a prison. Criminals ranging from pickpockets to murders were thrown into the keep and lived in squalor. The building had no roof so the rain would fall into the garrison on the ground floor where the prisoners were kept lying in their own mess. The conditions were horrendous, and they remained that way into the eighteenth century when prison guards would charge the public to walk around the prison like a freak show, humiliating the prisoners further.

In 1809, the Newcastle Corporation bought the castle and its surrounding Garth. Over the next fifty years it repaired the building and returned its roof. The castle keep is now owned by Newcastle City Council and still stands proud overlooking the Tyne and all her bridges.

As you can see the castle keep has everything you could ask for in a haunted building and is why it is visited so often by paranormal groups and has featured on television programmes. The ghost stories range from ghostly apparitions walking around the castle's cloisters to screams heard from the roof, but what about the most famous tales of this building?

A flower girl has been reported many times by many different people in the lower levels of the building. It is said that a figure of a small girl roams around the stairwells with a

basket. The smell of lavender or flowers is often smelled after she is seen or heard. Could she have been a visitor to the garrison when it was a prison? Or did she visit the castle to sell her wares when the castle was home to wealthier owners?

Many shadowy figures have been reported around the corridors of the castle keep and they are more often seen on the upper floors. Faces have been reported to peer over the ledges of the cloisters that overlook the Great Hall.

There are reports of a violent ghost that likes to scratch visitors, usually on their backs and necks. I can confirm seeing this happen first-hand. We were in the Great Hall when one of our team reported feeling an intense heat on their back, followed by a pain. As we lifted their shirt, there was a large red scratch down their back. It was red and the skin was raised, leading us to believe it had only just happened. No one could explain how this could have happened.

Also reported in the Great Hall was a ghost of a heavy-booted man. We had left a member of our team lying down in the area as we went downstairs, as we had heard a series of whistles. When we returned the lady asked who had walked around her. We explained that no one had been on that floor and she had been in the room alone. Her face turned white with fright as she got up to her feet and explained what had happened. 'I was lying on the floor calling out for a spirit to come close, when I heard someone enter the room. I turned my head and could see a pair of legs walk across the room behind me. They walked past me and left the room by the doorway on the left. I thought it was one of our group walking through.' It was at this point that we showed her the door she was indicating was locked and had been all night.

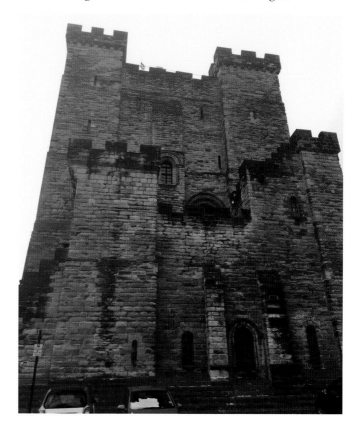

External shot of the castle keep.

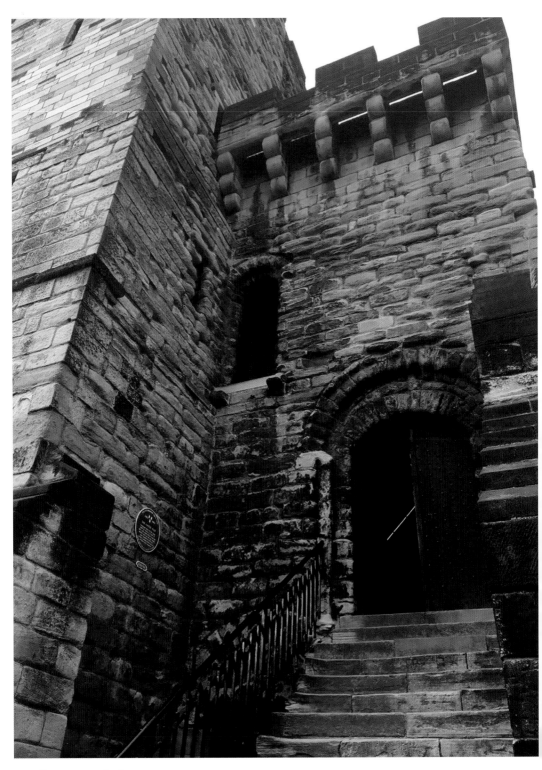

Entrance to the keep.

*Right*: Stairwell that is said to be haunted by a crying girl.

*Below left*: Medieval stonework.

*Below right*: Doors where banging is often heard.

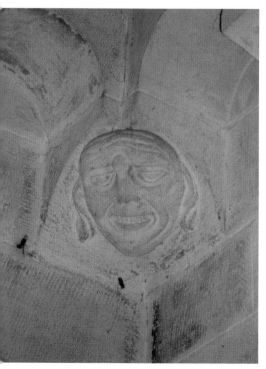

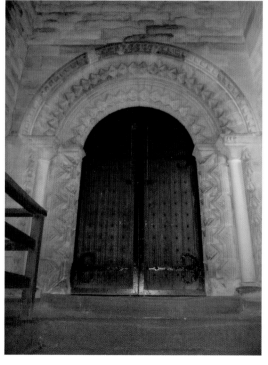

# The Cooperage

Now if you are standing outside the Cooperage you will notice how crooked this building has become due to its age, which is understandable as it has nearly 600 years of history. Believed to be built in the early 1400s using the timber of a sunken ship that was found in the Tyne opposite, the building was originally a home for a local merchant that plied his trade on the river. The wooden structure surprisingly survived the Great Fire of Newcastle in 1854. The building changed hands over the next four centuries before opening as a grocer's shop in 1853. However, in 1876 the building was bought by John Arthur Cooper, who was ironically a barrel maker. The building then took its name as the Cooperage. Six generations of the Cooper family would enjoy success on the Quayside before moving in the early 1970s.

In 1975 The Cooperage would open as a public house. It enjoyed success as a well known and loved place to go, especially at the weekend as Newcastle became world renowned for its nightlife. Unfortunately, the Cooperage closed its doors for the last time in July 2009 and has stood empty ever since. The Grade II listed building was recently added to the Heritage at Risk Register.

The historical importance of this building to Newcastle was further increased during two archaeological digs in 2003 and 2005. During these digs there were items found dating back to Roman times. They also included well-preserved pottery and wooden bowls dating from the fourteenth and fifteenth centuries.

The ghost stories of this building are not just linked to the Cooperage, but apparitions have also been seen on the stairs that run parallel to building. One of the more well-known tales is of a local man called Henry Hardwick. It is believed he was killed on the steps outside the Cooperage when a gang of press gangers attacked him. He ran away but was then caught. After a struggle he was murdered, and his body left on the steps. An Edwardian man has been spotted several times in the area. Could this be Henry?

Over the years of the Cooperage being a pub, many of the staff and landlords have spoken about the strange and unexplainable happening inside. Flying glasses, televisions that switched on and off, the feeling of fear when they were alone and sighting people that simply would disappear on further investigation.

The second floor is said to be home of a threatening and heavy presence. It has been described as a large dark mass wearing a hood or hat. In all instances of these reports, the people have become very scared and distressed while seeing this apparition.

One of the oldest buildings in Newcastle.

# Bessie Surtees' House

These two adjoining merchant houses date back to the early 1600s and are believed to be some of the finest examples of Jacobean architecture still standing in Britain. The houses would have belonged to merchants that traded on the river, much like the Cooperage. You can see by their size and structure they would have been owned by wealthy families of Newcastle.

However, if you look up at the five-storey building, you will see a blue plaque that identifies the window that was used for one of Newcastle's most famous escapes. In 1772, the building was owned by a wealthy banker called Aubone Surtees. His eldest daughter was called Bessie and had fallen in love with a local student called John Scott. At the time, the Surtees and the Scotts were not happy about the relationship between their children and tried in vain to stop it. On 18 November Scott, with the help of a friend and a ladder, helped Bessie leave her bedroom through the window. They then eloped to Blackshields in Scotland where they were married. John Scott would go onto become Lord Eldon and the Lord Chancellor. The couple would stay married until Bessie's death in 1831.

Most of the ghost stories of this house centre on the window above the plaque.

It has been reported many times that late at night people have seen a white ghostly face at this window.

The face is of a woman staring out into the street. The pale face has an expression of woe and looks as if she is wearing a scarf around her head. Most people believe this to Bessie herself sitting waiting for her lover to come and take her away. However, what if it isn't Bessie? Could it be her heartbroken mother hoping she'll return or one of her sisters looking out for the window missing her sibling during the cold harsh winter? All I can advise is return to the building on a cold November's night and look up and you never know who you will see.

The home of Bessie Surtees.

# The Guildhall

This area has been a busy part of the Quayside for centuries. In the fifteenth century a building called the Exchange stood in the area until it was pulled down and replaced by the Guildhall. Work began on the Guildhall in 1655 and took three years to complete. It opened in 1658, with the east end of the building added to by John Dobson in the middle 1800s.

During its earlier life the Guildhall was used mainly as a merchant's court and plays a significant part in the history of law and order in Newcastle. Murderers, thieves and pirates have all been tried in the building, but probably the most notorious use would

The historic Guildhall.

have been the trial of witches. Indeed, we know that a Witchfinder General visited the Guildhall during the time that the country was in the grips of fear from witch trials. Many men, women and children would have been held in the cells under the main part of the hall until they were either hanged or sent to the jails around the city. Many died in the squalor before they even saw a judge.

Press-ganging was rife on Newcastle's Quayside and the Guildhall was the meeting place for the press-gangers. They would gather up local criminals and drunkards and force them onto ships to work as they sailed to faraway countries. As the common way of working was to knock out their unexpecting victims with a blow to the head before bundling them onto a ship, there would have been a certain number of deaths. So, no doubt the body would have ended in the river in this area. In the nineteenth century the building would become home to the City Council. The building is now used for office space by Newcastle's City Council.

The current building has limited access but over the years there have been many stories about strange occurrences not only inside the building, but around its outside paths, especially the south side facing the river. Screams have been reported coming from inside the building in the dead of night, with faces seen at its windows. Are these the voices of the poor souls that were trialled for witchcraft or of the many criminals that found a gruesome end to their lives beneath the streets?

If you're walking alongside the building late at night and you see a figure of a man on south side of the building dressed in unusual clothes and holding his head, are you sure it's not a victim of the press gang looking for his way home?

# Dog Leap Stairs

Be ready to take a deep breath as we are going to climb this steep set of steps that take you to Castle Garth. However, as you get halfway up, take a pause. This thoroughfare connecting the castle to the Quayside was built in the eighteenth century and originally stood between two tenement buildings. We know it was present in the late eighteenth century as it's mentioned in the story of Newcastle's most famous bride, Bessie Surtees, who we mentioned earlier. It is said this is where she and her groom rode their horses up the steep steps to escape the chasing members of her family.

There have been many reports of people hearing the gallop of horse's hooves on the stairs followed by screams from below. People have reported feeling very uneasy and have tried to run up the top part as they have felt as if they are getting chased. It is believed that some of Bessie's chasing pack only made it halfway up the stairs before their horses fell backwards, with some of the men and horses being killed on the street below.

At the top of the stairs, if you look to your left, you will see railway arches. There have been sightings of a young girl crying in these arches. The witnesses all describe a small girl in a white dress bent over sobbing, but when the person who spots her walks over to see if she is all right, the figure simply disappears. Nobody knows who she is or why she appears here.

Dog Leap Stairs street sign.

The stairway where horses' hooves are heard.

# Old City Coroner's Court and Morgue

Nestled on the Quayside on the Newcastle side of the memorable Swing Bridge, the old City Morgue and Coroner's Court has a vast history not only within and around its four walls.

The ghost stories of the area are numerous, with its history even more intriguing. The site of the Swing Bridge is where the first known bridge over the Tyne was located in Roman times when it was called Pons Aelius. The original bridge was built in AD 120 and would span the river until fire destroyed it and half of the city in 1248. A second stone bridge was constructed in 1320 until the great flood of 1771 washed away a section of the bridge. The remains of the structure were removed, and a third bridge was built in 1781. In 1873 the bridge was decommissioned and removed to be replaced by today's Swing Bridge, which opened in the summer of 1876.

As we can see, disaster has struck the area numerous times and unfortunately with fire and flood comes a cost of lives. One story linked to the ghosts of the Quayside is of a little-known nineteenth-century celebrity called Thomas Ferens, or 'Tommy on the Bridge' as he became more widely known. Tommy was a partially blind and paralyzed man who would beg for money from the people using the bridge. He was known to become very aggressive and intimidating and became well known around Newcastle. The height of his fame came when he threatened to sue the council and stop the bridge from being opened as it effected his earnings.

Unfortunately, on New Year's Day 1907 Tommy was found collapsed in the snow at the bridge and was taken to a local workhouse hospital where he later passed away. It is said that if you are around the centre of the Swing Bridge when it is opened, you can hear Tommy shouting his profanities at the authorities or on cold dark nights as you walk between Newcastle and Gateshead a blind man may tug on your coat looking for some loose change.

The building is itself is situated on the edge of Sandhill, which dates back to the Middle Ages and is home to many historic public houses including the Cooperage, the Red House, Bessie Surtees' home and the Guildhall. Sandhill has a notorious past and was well known for murders, witch trials, hangings and press gangers, making this area probably the most violent part of medieval Newcastle.

It was originally built as the Swing Bridge toll house in 1876. The building only had one storey that sat on the bridge and was home to the toll keeper, who was responsible for collecting taxes on the goods being transported to and from Newcastle. It was

seen as a very respectable job and the single-storey house would have been seen as luxury accommodation for a working man back in those days. Over the following thirty-four years a number of families resided in the small building as the man of the house held the position of toll keeper.

In 1905, the city's authorities decided to abolish the city tax as it could no longer be justified and, in the summer of 1910, the taxes were stopped and the house was closed. The house sat empty for six months while its future was decided.

At the start of the 1911, the building was suggested to the council as a potential site for a new mortuary and coroner's court. The old mortuary was situated on the outskirts of the city and had fallen into a serious state of disrepair. It was decided that the toll house was perfect due to its location. It was detached from other properties, was inconspicuous and was ideally located on the banks of the Tyne. It would therefore be a perfect spot for the many bodies that were pulled from the Tyne due to suicide or tragic accidents on the jetties and ships that used the river. It was decided that a second floor would be added and the dank basement below the bridge would be gutted. The council would also have to add an access door to the basement through which the bodies could be transported. Work took place during 1914.

The new second floor was turned into a coroner's courtroom. The ground floor, which was once used as home, was converted into smaller rooms to be used as offices and waiting rooms. A staircase was built to lead down into the refurbished basement, which was now being used as a viewing room and storage for dead bodies. Alfred Appleby, the city coroner, opened the new City Coroner's Court and Mortuary in January 1915. He would serve the city in the role for a further thirty-six years before retiring with a knighthood for his services. For the next sixty years the building would be used. Thousands of cases were heard in the upstairs courtroom while thousands of bodies were stored in the cold dark basement.

In 1975, it was decided the building had become too small for a city with a growing population and a new home for the coroner was found in the heart of the city at Bolbec Hall, next door to one of our favourite locations: the Lit & Phil. The toll house was once again empty.

The house would stand empty until the early 1980s, when it reopened as a medical centre for the homeless. During this time the basement was used as an office for the busy Quayside Sunday Market. The building enjoyed a busy life at the heart of the Quayside until 1998, when it would close again.

In 2011 it reopened its doors as a local charity called Changing Lives moved in. They put the building to good use until earlier this year (2019). The toll house currently stands empty and without any occupants. However, this gives GHOSTnortheast a unique opportunity to investigate the building until new occupants are found. Stories from previous tenants have included pictures and fittings falling off the walls, doors slamming for no reason and voices coming from the upstairs rooms when no one else is in the building. Dragging noises, banging and footsteps have also been reported in the basement, with dark shadows seen on the lower stairwell.

When we investigated the building, we were overwhelmed at how many times the names Thomas or Tommy were reported on our various pieces of equipment, although this was only reported on the ground floor. Could this be of been Tommy of the Bridge? Strang banging was heard in the basement, but we couldn't find any natural sources for the banging as the walls are made of stone, yet the banging sounded more

metallic. These noises coincided with several reports of shadows on the staircase. At one point we stopped the investigation as we were expecting somebody to enter the room. These are the same reports we had heard from previous visitors. The basement was awash with reports of strange noises, temperature drops and light anomalies. Could these be reminders of the days of the morgue or just natural occurrences?

*Above*: Upstairs where footsteps are heard.

*Left*: Staircase from the first floor.

*Right*: Basement stairwell where shadows have been seen.

*Below*: The basement where the morgue was housed.

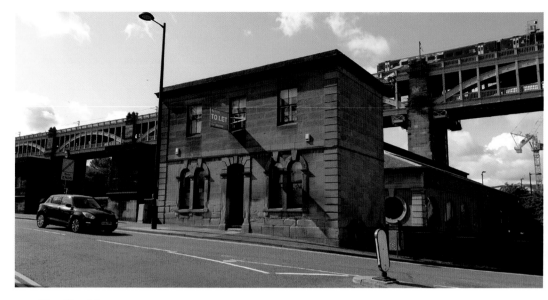

The City Morgue.

Swing Bridge where ghosts have been spotted.

# The Theatre Royal

The Theatre Royal must be one of the most iconic buildings in the North East and one of the most recognised landmarks after the Tyne Bridge in Newcastle. The Theatre Royal stands on the world-famous Grey's Street, which has been voted the most beautiful street in the world on numerous occasions and is a fine example of nineteenth-century architecture at its best.

As always, GHOSTnortheast starts its search on the land that it's built on. The back of the building stands on Pilgrim Street and would have been part of the monastery that stood in Newcastle nearly 2,000 years ago, which unfortunately caught fire and killed many of the Novocastrian monks that lived and worked there. We can't be certain, but we think the Theatre Royal would have stood roughly where the farm and stables were built.

The monastery served the pilgrims that would travel across the Tyne to visit Jesmond and then continue their pilgrimage up to Lindisfarne, giving their name to Newcastle's central Pilgrim Street.

Moving further forward in time, the building would have stood in the grounds of the sixteenth-century mansion house that stood on the site of the Franciscan friary. This was called the 'Newe House'. When Charles I was captured by the Scots in 1646, he was held as a prisoner in the Newe House until his release in 1647.

The manor was owned by Sir Francis Anderson until 1675, when he sold it to Sir Thomas Blackett. The Blacketts were to own the land for over a century until in 1783 it was sold to a local master builder called George Anderson. His son Major Anderson later renamed the area Anderson Place. Major Anderson later donated the 6-ton bell to St Nicholas' Cathedral that is still rang today and is known as 'the Major Bell'.

After his death in 1834 the 12-acre site was sold to Richard Grainger for little over £45,000. Once Grainger had the site, he made plans for redevelopment. The City's Corporation were hesitant to allow the building project due to the vast areas of open land. However, due to the quality of Grainger's previous work at Old Eldon Square and the Royal Arcade, the public signed a 5,000-strong petition and the Corporation allowed the work to begin. During the project, Grainger had to demolish the butcher's market and the original Theatre Royal that stood on Moseley Street with the agreement he had to rebuild the theatre for the people.

During the next five years Newcastle city centre was transformed. Over 700 workmen removed over 5 million cubic feet of earth to create nine streets that still stand today. The most impressive and splendid is Grey's Street. Grainger employed local architects John and Benjamin Green. The pair were also known for local building the Lit & Phil Library, Grey's Monument and Penshaw Monument in Sunderland.

Grainger explained that he wanted the theatre to be the centre of his grand design for Newcastle.

On 20 February in 1837 the doors of the Theatre Royal opened for the first time. The *Merchant of Venice* would be its very first production. The theatre became an instant hit but unfortunately after a performance of *Macbeth* in 1899, tragedy would strike the grand building. The fire destroyed the interior of the theatre, which had to be redesigned. A man called Frank Matcham was commissioned to bring the building back to its former glory. Indeed, the theatre's restaurant, Matchams, was named after him. Luckily the exterior of the building was undamaged and the frontage of this fantastic Grade I listed building still looks the same to this day.

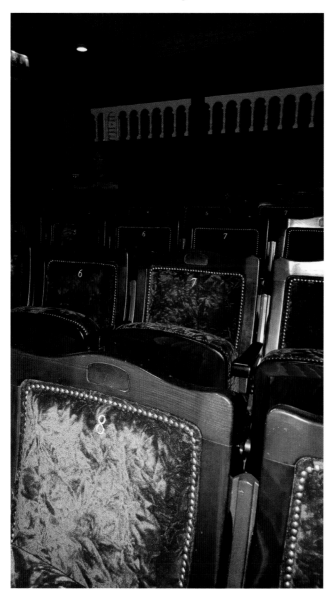

The Grand Circle.

The interior construction took nearly two years to complete but finally the theatre reopened on 31 December 1901. Over the years the theatre underwent some restoration, notably during the late eighties. In March 2011 the theatre went dark. For the first time since the great fire the Theatre Royal closed its doors to be completely restored and expanded so it could house modern performances. It reopened its doors in September 2011 with a performance of *The Madness of George III*. Ironically, it was George III who gave the theatre its royal charter.

As with all theatres the Royal is no different for having its share of ghost stories. A grey lady has often been reported in the upper circle. It is believed that she jumped to her death after being spurned by her lover. Monks have been reported in the area, footsteps in the back corridors and noises on the stage when no one is around.

The main auditorium and under the stage have delivered some extremely interesting reports. People have described seeing a person moving around the seats then into the aisle. After calling out several times with no response, they have gone to see who was in the area as they thought it was one of the theatre's staff or a member of the public that had overstayed their welcome. No one was found and all staff were accounted for.

Indeed, I can account for one of the paranormal stories. I was investigating the location with the GHOSTnortheast team when three of us were under the stage. We all heard footsteps above us on several occasions. However, every time we went back up to the stage, there was no one present. We had a camcorder recording the stage area at the time and we played back the footage expecting to see who was treading the boards above us. We were shocked to see the stage had remained empty during the entire night.

A theatre is a beautiful building when filled with people laughing and clapping, but it can take a completely different complexion when it is dark and empty.

The Theatre Royal.

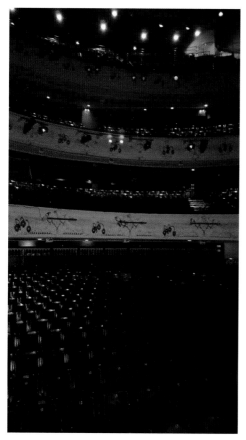

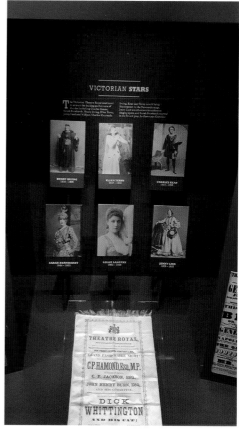

*Above left*: Seating area where the ghost of a lady is spotted.

*Above right*: History of the theatre.

*Left*: Stage door.

# John Lewis & Partners, Eldon Square

In the centre of the city is Intu Eldon Square, a typical city centre shopping centre. One of its entrances is on Northumberland Street and its other main entrance backs onto Old Eldon Square. As you enter the mall and walk past its numerous shops, cafés and boutiques you would not think for one minute about any sort of paranormal activity or ghost stories.

However, in the centre of the mall you will find John Lewis & Partners. Looking at the building with its exterior windows filled with the fashion items that are needed for your Saturday night out or the latest technological breakthrough for your living room or kitchen, you would be forgiven for going in to browse it's racks of clothing or gondolas full of merchandise without giving a second thought to why it would appear in a book like this. However, the department store holds some extremely interesting ghost stories. One ghost has been reported so many times that the partners (staff members at John Lewis) have given her a name.

Why would a seventies-built shop have any ghosts? Part of the building sits on land that was used in the Victorian era as a mission or a workhouse. These old workhouses were horrific places to live and were full of the poor and sick.

Another part of the building is on Old Eldon Square, which we know was part of the old monastery of Newcastle. The monastery chapel was nearby, so the square would have been the graveyard. Some of the stories of the building may link into this history.

One assistant described seeing a Victorian-dressed lady in the children's shoes department and thought it looked like she was looking for something. She was on bended knee and the assistant was puzzled at her style of her clothing. As the assistant finished with her customer, she went to speak to the lady, but she had gone. The assistant couldn't recall seeing her leave but could not verify that she hadn't.

Also in this area there have been reports of sobbing. The noises have been heard as the store is closing and there is no one around. Children's shoes is next to the toy department and there have been numerous reports of items falling from shelves for no apparent reason. As assistants are walking past, it has been known for toys and tickets to fall into the aisles with no natural explanation. A woman has been spotted through the locked stockroom window and when the assistant has opened the door to ask what the person was doing, she has simply vanished.

Another report on this floor was when a partner had walked through the shop floor early in the morning before his shift. He saw an elderly lady walking down through the dresses and skirts on the opposite side of the floor and he shouted good morning.

He walked a little further before realising he didn't recognise the lady and she hadn't responded to his greeting. He turned on his heels and returned to the spot only to find no one was in the area. He said there was no way she could have left the floor, as the exits in the area were all locked.

Probably the most convincing story from the building involved a visiting contractor. The gentleman was working a night shift, up a ladder fixing the lights, again on the first floor. He looked down and saw an old woman at the bottom of the ladder and presumed it was a member of staff doing some work on the shop floor. He spoke to her and didn't think about it when she didn't answer and turned and walked away. It wasn't until he mentioned to the security team of his encounter with a partner that the security team told him that there was nobody in the building except for himself and security. The story is that the building contractor packed up his equipment and left the job. One of his colleagues had to return later to finish the work as he said he would not return to the store.

The elderly lady is said to appear more often when there is construction work, or a major change being made in the store, and the store partners have now christened her 'Ethel'. Nobody knows who Ethel is or why she visits the store at certain times. However, John Lewis Partners are known for loving their business and taking their co-ownership very serious, so is Ethel a partner from days gone by and is just checking that the store is being looked after in her absence? Or is she someone from further back in Newcastle's history curiously looking at today's changing world?

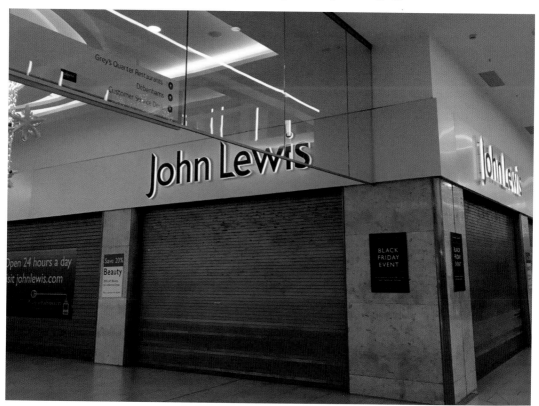

John Lewis.

# The Old George Inn

Situated in Old George Yard just off the Cloth Market, the Old George Inn can boast it is the oldest working public house in Newcastle. Indeed, as you walk down the short alleyway to the yard you can be excused if you feel that you have been transported back to sixteenth-century Newcastle or you are walking in a film set of Harry Potter's Diagon Alley. The medieval walkway has been kept in excellent condition and helps set the mood as you come across the entrance to this extremely interesting and historic pub.

The Old George was built in 1582 and was within the old city walls. It would have been used by the small population that worked in the Cloth Market, cathedral and castle keep. The building still has all the original features and even though there are areas where modernisation has had to happen, you can still feel what drinking a cup of mead or ale would have felt like 400 years ago.

However, we need to jump to 1646 and the visit of what would be the Old George's most notable patron. It is believed that Charles I was held captive in Newcastle by the Scottish in this year. His captors allowed King George to visit the pub and you could say it became his local during the time he was incarcerated in a building on the nearby Pilgrim Street. You can visit the 'King Charles I' room where the chair that he sat in is still on display and it is around this era that most of the Old George's ghost stories revolve.

The most well-known and popular paranormal reports are of a ghostly apparition appearing in the king's chair. This has been described as a white of grey mist that seems to be forming into a figure seated in the chair. This is accompanied by many sightings of orbs and light anomalies.

Staff and patrons have reported many usual occurrences throughout the building – figures on the stairs, shadows in the function room and unexplained voices around the bar area when the pub is shut. There have also been reports of glasses flying off tables and chairs that move by themselves. There is a recording of an unusual orb of light moving across the room, which was recorded on the building's CCTV. The owner had watched the footage back after a series of alarms had been set off around the bar area. It shows a slow-moving ball of light that simply disappears in the middle of the room. It is a strange anomaly and doesn't resemble the usual dust or insect orbs that are shown in a lot of paranormal video recordings. Is this King Charles looking for his favourite tipple?

Other paranormal reports at the inn include a man and his dog that are seen around the pub and then they disappear. Faces have often been reported in the windows even though the pub is closed and locked up.

So, if you visit the Old George Inn to sample its food menu or to have a pint, keep an eye out as you might just see ghost royalty.

*Above left*: Staircase upstairs where ladies have been seen.

*Above right*: The old alleyway outside the Old George.

*Left*: Ghostly entrance.

*Above left and above right*: The Old George.

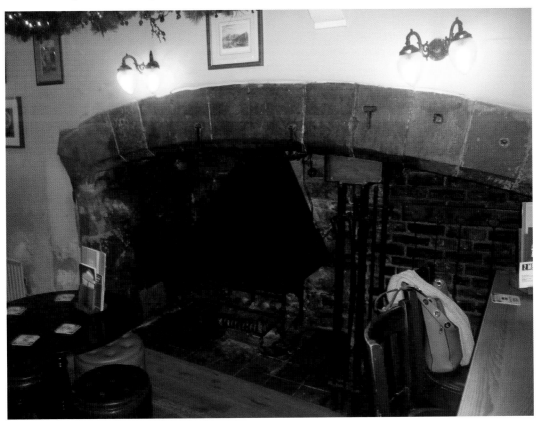

Original fireplace near to where the king has been seen.

# Life Science Museum

The Life Science Museum, which is situated in Times Square, was only built and opened in 2000, so why would such a young building be full of stories of ghosts and reports of paranormal activity. Well, if you delve into the history of the land on which it sits, you will understand why the area becomes a little more eerie as the sun sets across the Tyne.

Times Square and Life are built on an area of Newcastle called Forth Banks. Not only is this area of interest, as it is where part of the old city walls ran in the early days when Newcastle was part of a Roman settlement, but it is also the site of the Newcastle Infirmary. Newcastle Infirmary opened in 1753 and was funded by a subscription basis. The people who had donated to fund it had a right to give letters of recommendation to the poor so they could get much needed healthcare.

As the City grew, so did the need for hospital care and over the following 150 years, the hospital would be extended on three occasions, all funded by local businessmen and landowners. However, the need still grew as Newcastle was home to some very dangerous industries including mining and shipbuilding.

In 1887, the subscription method was abolished as it had become nearly impossible to manage and the hospital was to be funded by many of the local companies where the patients were employees. The infirmary was to continue its service to Newcastle until 1906, when a new larger hospital was built opposite Leazes Park. The healthcare of Newcastle was transferred to the Royal Victorian Infirmary, which still stands today.

The infirmary was to stand empty until 1956 when it was demolished and the land flattened. The land stayed empty to the turn of the twentieth century when the idea of the Centre of Life was born. This would include office space, pubs, clubs and a new museum called Life Science Museum.

The building application was passed by the city council and work began in the late 1990s. However, work on the site would stop as quick as it started as the building contractors started to dig up the land to build the foundations. A pit full of human remains was found. Thousands of body parts were found, and the initial thought was that they had discovered a plague pit. Government officials were brought in and the body parts were removed by specialists in hazmat suits as they feared the area could be contaminated. It is documented that they had found forty-three full human skeletons and thousands of limbs. The limbs all seemed to have marks made by saws and hammers. The area was deemed safe to continue with the building work as it was verified that they had found the waste pit from the infirmary.

With so much history on this site it is reasonable to see how the modern building has its fair share of ghostly tales. One story is of a Victorian dressed child seen near where the 4D Motion ride is housed. Some visitors were leaving the building and

asked staff why they had people dressed up in Victorian outfits. The staff replied that there was no one in the building dressed up and as it was the end of the night, they were their last visitors. With this the visitors became unnerved and told the staff that they had just seen a child dressed in Victorian clothing standing outside the room. When the staff checked there was nobody to be found.

Various light anomalies have been reported in this room. They were captured on the CCTV cameras. This could be dust or an insect but the movement and the disappearance of these 'orbs' was very strange. A local radio station was recording an interview in this area about an upcoming paranormal event. The organisers had set up some equipment in the room that detected movement and electromagnetic field changes to demonstrate what would be happening at the future event. However, they would all be surprised as the equipment started to react during the interview. The presenter asked how the equipment was being set off. The simple answer was nobody knew as no one was near the equipment.

Other reports in the building centre around an underground maintenance corridor that sits at the back of the museum. Connected to the corridor are workshops for the onsite maintenance team. There are many tales of paranormal activity in this area, including ghostly voices and items moving by themselves. It's said that the workers have put tools down and walked away to continue their jobs only to return and the tools have vanished. The tools then reappear in a different place or will turn up later in the day.

At the paranormal event I mentioned early, in the corridor the equipment that was used by the investigation team was very active and a video was recorded that showed a shadow appear from a wall then quickly return to it. I have seen the video clip and I must admit that I had no explanation for what had caused the shadow.

The interesting parts of all the ghost stories at the Life Science Museum is that the locations that provide us with the most sightings would have been where the infirmary would have once stood.

3D room where a Victorian family has been reported.

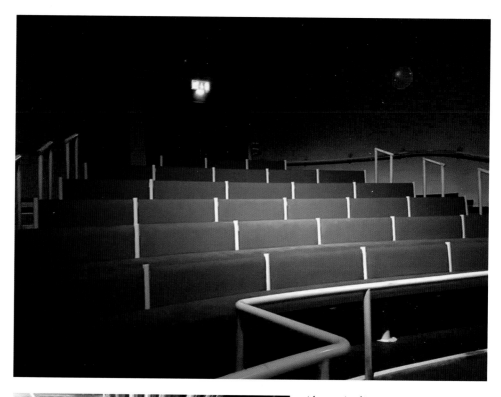

*Above*: Auditorium.

*Left*: Basement corridor that would
have been the old morgue.

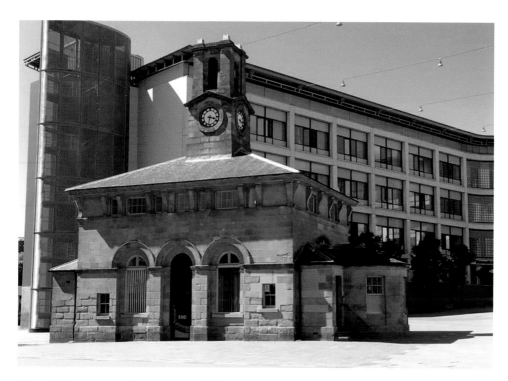

*Above*: Victorian Market House where ghostly voices have been heard.

*Right*: Corridor that was the location of strange readings on our equipment.

# Blackfriars

Thirteenth-century Newcastle housed no fewer than four friaries across the city. The links to the church were very strong, hence Newcastle's original name of Monkchester. Is this the reason that there have been hundreds of sightings of ghostly monks over the years in many parts of the city?

Blackfriars is situated in the western part of the city, next to the Chinatown area. Today the building is a restaurant complete with a banqueting hall and it sits in front of the original grassy courtyard. It competes with the castle keep as one of the oldest buildings in Newcastle and has been perfectly restored to keep its history alive.

The Black Friars first appeared in Newcastle in 1239. When they arrived, they had very little money or valuables as their religion would not allow them to own anything. However, a family of sisters donated some of their land to the friars and a local man called Sir Peter Scot helped them to raise funds to build their first friary on the site.

Over the next two centuries the buildings grew including a monastery. Such was the grandeur of the cloisters and banqueting hall, Henry III stayed at Blackfriars in 1334 when he met with his Scottish counterparts.

Unfortunately, Blackfriars was to fall victim of Henry VIII. In 1536 the king started his Reformation. The church and some of the building were gutted and destroyed, with the land sold off to the mayor of Newcastle. The friars were thrown out of their home and alterations began on the friary.

By the start of the seventeenth century the buildings had been rented to several of the trade guilds of the city, who made use of the space for their various occupations. As time went by, the buildings fell into disrepair and during the 1800s and 1900s the buildings were deemed unsafe and closed. It wasn't until 1973 that the building was restored. The Newcastle Corporation bought the land and over the next eight years Blackfriars was finally returned to its former glory.

Over the years there has been many sightings of ghostly figures in black cowls over their heads. The figures are often described as monks and some reports have also included people hearing chanting at the same time. The sounds of male voices singing has been heard in the monastery area, but this has also been accompanied by screams and angry shouts.

White mists are seen on the grassy area where the monastery once stood. Could this be the returning friars that were reportedly murdered by the King's Guard hundreds of years ago?

Blackfriars restaurant has also had reports of the paranormal over the years. Doors slamming shut by themselves have often been heard and seen. Furniture and fittings move around when there was no one in the building. There has been voices heard in the banqueting hall followed by laughter but when investigated further the hall is empty.

The upper floors are said to be visited by a dark hooded figure that disappears through the walls between the modernised layout. A figure of a nun has been spotted walking the cloisters and she is followed by the smell of herbs and flowers. We do know part of this building would have been used as a hospital caring for the older monks. Could the nun be from the nearby nunnery, visiting Blackfriars with her medieval medicines?

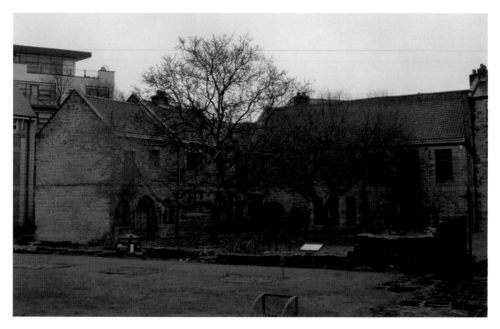

*Above*: Blackfriars.

*Right*: Old window from the original monastery.

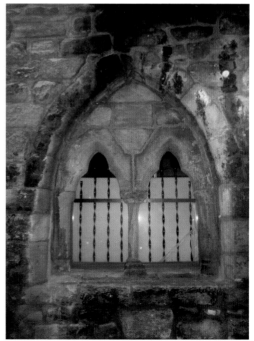

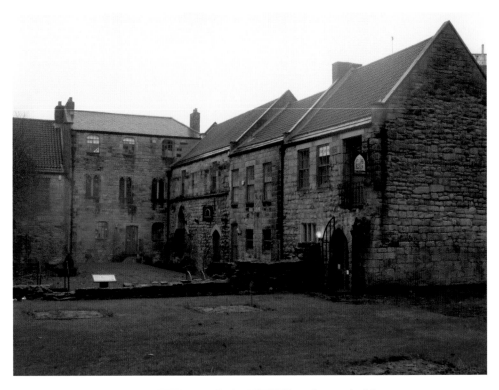

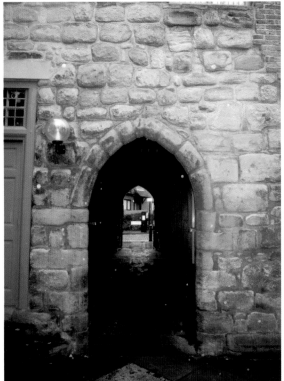

*Above*: Blackfriars.

*Left*: Corridor that is visited by the ghosts of monks.

*Right*: Remains of the monastery.

*Below*: The site of the old church.

# The Tyneside Cinema

Continuing the theme of the friaries of Newcastle, we move on to the Tyneside Cinema. You would be forgiven for wondering what this 1930s art deco cinema has to do with ghost stories of the monks of the city. However, the cinema is situated on the corner of Pilgrim Street and High Friar Lane.

Pilgrim Street's history dates back as far as Newcastle's. It was named after the pilgrims that flocked to the region during the Dark Ages. A vision of the Virgin Mary had been seen in a nearby village north of the town and the story had been reported across Europe. The village was named Jesus Mound and the main route from the south was across the Tyne by bridge and up a road through Newcastle. Today the village is called Jesmond and the ruins of the church are still visible. The road through Newcastle was called Pilgrim Street.

High Friar Lane is on the site of Greyfriars and it is suggested that the house of the High Friar was in this area. It is known that during the days when the pilgrimage was popular, the friars of Greyfriars would stand on the road offering bread and water to the travellers walking past.

Greyfriars was built in 1237 and it suffered the same fate as Blackfriars during Henry VIII's Reformation. The area became the site of Anderson Place, which was a vast estate for Sir Walter Blackett. He lived there in the eighteenth century before bequeathing it to George Anderson. Finally, the house and land were passed to Richard Grainger, who demolished the area to build the now famous Grey Street. This leads us to understanding why there are stories of monks seen in the cinema.

The building has been home to some very interesting reports throughout the building. Strange noises in the Classic on the ground floor could originate in the Metro train system that passes below, but staff have reported voices and banging late at night when their patrons have gone home, and the trains have stopped.

A dark hooded figure has been reported. It has been described as looking like a monk. The witnesses have all said that they have felt uncomfortable and scared by the presence. During several paranormal investigations that I attended in the cinema I was told by other attendees that they thought they had seen a dark shadow. This was accompanied by people wanting to leave the area or becoming very agitated. Strangely these reports came mostly on the top floor where 'the Electra' screen is housed and not on the lower floors where the monastery would have been.

Are these reports just an old building playing tricks on the eye? Is it the psychology of being in a dark quiet cinema or are they the ghosts of the monks that would have been killed on the site during Tudor times, still taking care of their monastery?

The entrance to the Tyneside Cinema.

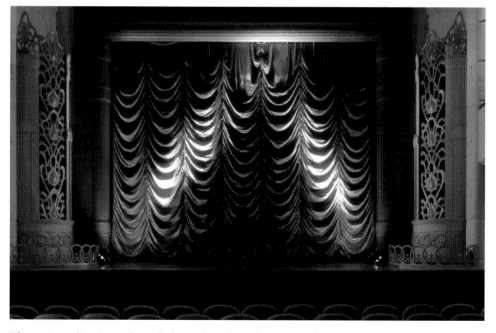

The main auditorium where dark shadows have been spotted.

Pilgrim Street, which was the main throughfare for the medieval pilgrims.

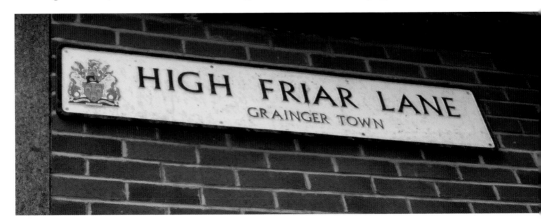

Sign showing High Friar Lane, named after the building that once stood there.

# Holy Jesus Hospital

The Holy Jesus Hospital not only has its own history but is also the site of the last friary I am going to write about, and that is Austin Friars. They appear in Newcastle in 1290 and a year later they were donated land by William Baron of Wark to build a friary. Over the following years the monastery grew and was used by travellers as it sat on one of the main northern roads out of the city towards Scotland. In 1306, Edward I granted an extension to their land so they could extend their burial grounds.

As with the other monasteries in Newcastle it was closed after Henry VIII's Reformation and the monastery was stripped of all valuables. The building was left standing due to a request for it to be used as a Northern Council and the Crown granted the request. During this time a stone tower was built, which still stands on the site today.

The friary buildings were demolished and the Holy Jesus Hospital was built on the land 1681. The hospital was built with funds raised by subscriptions from the Freeman of Newcastle. The hospital went from strength to strength, with a second building added in 1730. The hospital would serve the people of Newcastle until it was closed in the twentieth century due to the hospital being uninhabitable.

The building found a new lease of life in 1971 when the building was transformed into a museum. The John George Joicey Museum was named after a local coal merchant and housed many attractions including an effigy of a fifteenth-century knight that had been discovered near to the tower during building work. The museum closed its doors in 1993 for the last time and is now owned and used by the National Trust's Inner-City Project.

There have been many sightings of monks in this building including sightings of a knight. However, there is no evidence that the knight ever attended the location, and this could be influenced by the finding of the fifteenth-century effigy.

I was told a story a few years ago by an old friend about the Holy Jesus Hospital when it was a museum. He recalled that he had visited the museum on a school trip. He was only nine or ten at the time and he remembered that part of the building had been recreated as a Victorian classroom and the children would dress up in Victorian clothes and take part in a Victorian class. He said that he had seen a young boy sat at the back of classroom. He didn't recognise him from his classmates and said that the boy's clothes were unusual as they were from neither the modern era nor that of the Victorian style they were wearing. The boy looked a bit ragged and dirty. My friend continued that he had started to concentrate on what was happening in the class and when the class ended, he turned to look for the boy and he was gone. I asked my friend if the boy could have got up and left, but he insisted that he would have seen anyone leaving the room. He said that he hadn't told anybody the story of the boy

until years after as he feared being ridiculed, but he could still clearly remember what the boy looked like.

Recalling this story still sends a shiver down my spine. Had his eyes been playing tricks on him or did he see an apparition from the hospital or adjoining nineteenth-century soup kitchen?

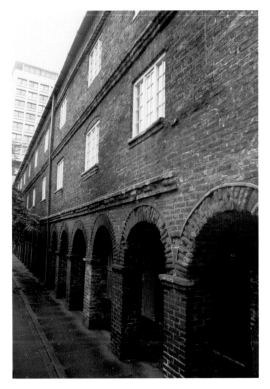
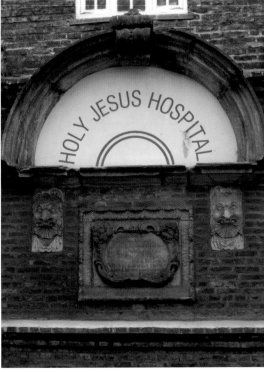

*Above left*: The cloisters.

*Above right*: Sign of the hospital.

*Left*: Holy Jesus Hospital.

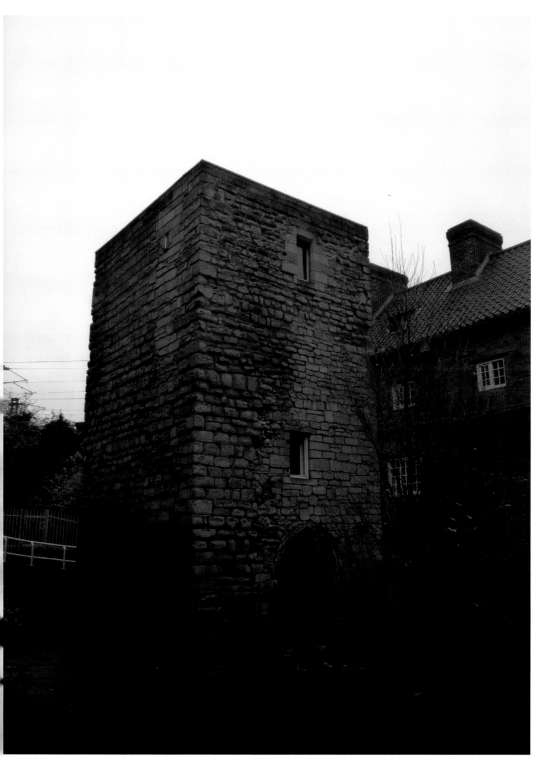

The only original part of the monastery left standing.

# The Town Moor

The Town Moor is a large parkland on the outskirts of the city centre. Every year it hosts 'The Hoppings, Europe's Largest Travelling Funfair'. It is the site of Exhibition Park and is used by walkers, runners and cyclists. It is also home to hundreds of cows that can graze on the moor as they are owned by the Freemen of the City. So why would this area be the home of many spooky stories and ghastly tales?

Centuries ago the main route into the north of the city was over the Town Moor. On this route you would have been greeted with sights of dead bodies and tortured souls as you got to the city entrance at Gallowgate. The Town Moor was home to Newcastle's gallows, and it was where many of the murderers and thieves ended their days in the most gruesome ways imaginable. Their bodies were put up on display to warn visitors to behave and abide by the laws of the city. The exact location of the gallows is unknown and there are also claims of the site being on Barrack Road where BBC Newcastle's studios now stand. Reports also suggest Exhibition Park and Cow Hill are prime sites.

The Gallows Gate, now named Gallowgate, is at the edge of the city walls and is now more famous for being the home end at St James' Park, the stadium of Newcastle United Football Club.

We can't mention the Town Moor's grim history without mentioning its most famous executions, those resulting from the Newcastle Witch Trials. During the witch trials fifteen people (fourteen women and one man) were hanged for the crimes of witchcraft and sorcery. During 1650 the country was in a panic about witchcraft. The Scottish Witch Trials had been making news throughout the country with tales of people turning themselves into animals or casting spells on their foes, when, in reality, it was a group of men calling themselves Witch Finders who were visiting small villages and towns charging the local councils to rid them of the Devil's spawn.

A Witchfinder from Scotland attended the trials that were held at the Guildhall on Newcastle's Quayside, and even though he was shown to be a fraud, the fifteen locals were put to their death in the largest public hanging for witchcraft in Europe.

Ghostly reports of ladies screaming in the night, dark shadows crossing the public paths and the feeling of being followed are just some of the numerous reports that I have heard over the years about the Town Moor. Are these just natural occurrences that are heightened by walking through the dark parkland or are they the ghosts of troubled souls of days gone by?

I was told one story back in the early eighties. My sister and I can clearly remember being told the story of the Edwardian man that walks Exhibition Park by our grandmother. He was a tall, well-dressed man and would walk through the park oblivious of what was happening around him before stopping at the boating lake,

where he would just stand and stare at the water. If you approached him, he would disappear into thin air. I don't know if this was a genuine ghost story or just an old wife's tale, told to a pair of gullible children to keep them entertained. However, there always seems to be some truth in folklore.

*Right*: BBC Studios, believed to be the site of the gallows where the witches were hanged.

*Below*: Exhibition Park.

Today's Gallowgate is overshadowed by St James' Park.

Today's Town Moor.

# Cosmic Ballroom

Stowell Street sits parallel to the city's old west walls and was built in 1824. The original street was a line of residential town houses for the more affluent residents of the city. The opposite side of the street that backed onto the walls was full of warehouses. During the late 1970s and early 1880s the area became more well known as Newcastle's Chinatown – and it still stands there today.

However, between the numerous restaurants and shops you will find a small nightclub called the Cosmic Ballroom. The building originally opened in 1966 as a casino called the Bird Cage. In 1974 it transformed into a nightclub called the Stage Door.

The Stage Door would delight Geordie partygoers until 2006 when the club was forced to close after a thirty-year history that boasted a lot of celebrity visitors. The club was then reopened as the new Cosmic Ballroom.

Several years ago, I was approached by a friend of a friend who asked if I would go to the club and review some unusual CCTV footage. Of course I was intrigued and arranged to meet the gentleman at the club. He led me into the office, and we sat and watched the screens of the several cameras that covered the nightclub's two floors. He played back a piece of footage that had been recorded three days previously. The club was shut for a couple of weeks as it was in the middle of a refit. The footage showed an industrial-sized tin of paint on a table near to the stairs. Two workmen had their backs to it when it flew off the table onto the floor. We rewound and played the footage several times. The tin's flight path suggested that it had been pushed from behind with some force, yet the recording clearly showed nobody was anywhere near the table or the tin of paint. The gentleman was adamant that there was no one else in the building at the time and the workmen were extremely shaken by the event, which ruled out a prank, not only due to their reaction but I also could not see why you would spill a tin of paint all over a brand-new laid floor. When I went down to the area, there were several tins of paint and I was shocked at the weight of these. It would need to be pushed with more strength than I originally thought. I have no reasonable explanation for what I had seen.

I started to delve into the history of the building and was fortunate to know some people who could remember the days of the old Stage Door and some of its more colourful stories. After the people recounted their stories of their favourite nights out, they all seem to know ghost stories from the building. There were the usual tales that surrounds pubs where glasses flew off the bar by themselves or chairs that changed position, but three stories were repeated several times.

A story of a dark figure that manifested upstairs in one of the booths and then would also be spotted on the staircase near the toilets. When the figure was approached it

simply disappeared, which was reported by both the people who had worked at the Stage Door and people who had been patrons during the eighties.

There were tales of a monk who had been seen walking through the wall at the back of the nightclub and was oblivious of his surroundings. Although this story would be apt as Stowell Street sits on the edge of the monastery of Blackfriars, I did not speak to anyone who was an eyewitness to this phenomenon and it was a story that a friend had told them.

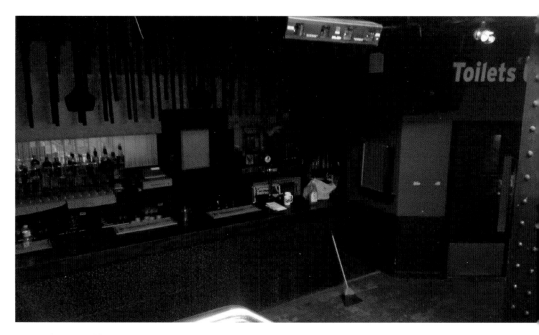

*Above and below*: Internal shot of the Cosmic Ballroom.

The third story was the sound of heavy footsteps from above when the club was shut. The footsteps were heard in the downstairs bar and when the staff ran upstairs to see who was in the club, no one was found. This is a report that I would witness myself.

The club owners agreed to allow us to spend the night in club while it was still closed for refurbishment to investigate the various stories of activity. During our investigation we witnessed some extremely strange events, most notably footsteps coming from above our heads while we were on the ground floor. On several occasions we were sitting downstairs working with various pieces of equipment when we heard someone walking across the floor above. These were heavy footsteps and lasted several steps. On one of these occasions we heard what sounded like a door shutting. We immediately ran upstairs to find nobody in the building. This was more disturbing as we knew both main doors were locked.

The night was filled with bangs and taps that we still don't know if they were from a natural source, but the footsteps were loud and clear. This was also coupled with several of the team with me feeling uncomfortable and none of them wanted to go anywhere by themselves, which is strange for them.

So, are the only spirits in the Cosmic Ballroom the ones that are sold behind the bar or is it still being visited by spirits of the city's history?

Stowell Street is a historic street that is now home to Chinatown.

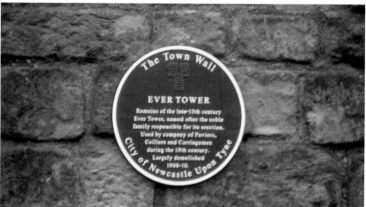

The boundaries to the city where many folks lost their lives.

# The Flat on West Road

West Road is the main route into the west end of the city and is built over Hadrian's Wall. The road passes many Roman sites including a large garrison that was known as Condercum. People living around the area have often told stories of sightings of Roman soldiers marching up and down the road or standing guard near to where the West Gate entrance into the city would have once stood. I have also heard many reports of haunted houses and flats in this area but was taken aback when a good friend told me about the strange activity that was happening in his flat on West Road.

I have known this friend for many years and he had never shown any interest in the paranormal. We had never discussed whether he was a believer or a sceptic. Our conversations were mostly discussions of our local football teams or the latest video game release.

One night we were talking and out of the blue he said, 'I think my flat is haunted,' then started to laugh nervously. At first, I thought it was a joke and awaited the punchline. He then went on to describe what had been happening. He had moved into the flat about a year earlier and settled in quickly. He said it had taken some time to redecorate as the flat must have been previously occupied by an older person judging by the décor. It had started with knocking at the front door. He said in one night alone, he had opened the door nine times thinking some local children were playing games. It got to the point where he was hiding behind the door waiting for the knock so he could catch them in the act, but every time he opened it, no one was there. After a few nights of this, he had decided to ignore it and turned up the TV as he thought it must be something to do with door or its structure. After a couple of weeks, he noticed the knocking had stopped.

A few days later he went into his kitchen to find his kettle was switched on. He said he knew he hadn't boiled the kettle and switched it off. This continued for the next few weeks until he got to the point where he was unplugging his kettle from the wall when he wasn't in the kitchen using it. He explained that he had started to feel uncomfortable later in the evenings. He said he had the feeling of someone stood in the doorway behind him when he was sat on the sofa but there was nobody there when he looked. It got to the point that he rearranged his furniture so the back of the sofa was against the wall.

I asked him if he had ever felt threatened? He said no, it was just a feeling of being watched. He added that he had been in shower several times and had to get out and look around the flat as he was sure he had heard someone in the bedroom.

After numerous conversations we decided that most of the activity was centred around the hallway from the front door to the bedroom door. Remember this was a

decade ago, and I didn't have the equipment that is available to us today, so all I set up a was motion sensor webcam in the hallway. After a couple of days, my friend rang me and told me to check my email. Much to my surprise we had captured a white mist that moved from the front door towards the camera. We tried everything we could to replicate the pictures but had no natural explanation for why this mist had appeared inside a warm central-heated flat.

By now my friend understandingly was reading through his lease to see if he could find a loophole so he could move, but unfortunately there was nowhere in the contract to say you could leave if you find a ghost.

I investigated the history of the flat and with it being on the West Road knew of many stories of hauntings but these usually involved Roman soldiers, so I found it difficult to believe that a member of a Roman legion would be switching on kettles. However, I did find that a previous tenant had died in the property of natural causes. Apparently, they had been found in the hallway but had died before the ambulance had attended.

As we were at the point where we would try anything to help my friend get a good night's sleep, we contacted the local church and asked them if they would send someone out to bless the house. Nearly a decade later my friend still lives in the flat and has said that he has never been bothered since.

Was this just several coincidences and over imagination? Or did my friend have an unseen lodger that was not happy sharing the space? I will say the webcam footage still sends a shiver down my spine.

West Road.

# The Mansion House

On the outskirts of the city is a leafy suburb called Jesmond. This is the place you'll find one of the oldest ghost stories in Newcastle. It is said that in the eleventh century an apparition of the Virgin Mary holding the baby Jesus in her arms appeared on a rock in the middle of stream now known as Jesmond Dene. The story became well known around the world and led to pilgrimages to Jesmond to see where the vision had been reported. Such was the demand from pilgrims that a small church was built during the thirteenth century and you can still visit the ruins of St Mary's Church on the banks of the Dene.

Jesmond Dene also has a stream of ghostly stories that are a little more macabre. It has been home to many of the more common ghost sightings such as white misty figures or dark shadows between the trees. There are stories of Devil worshippers using the more secluded areas of the woodland to practice their satanic rituals. Perhaps linked to this have been sightings of hell hounds, witnessed by people seeing large black dog-like shapes running through the forest on the nights of a full moon. Then there's the eerily quiet area of the park under Armstrong Bridge, which is home to an unofficial pet's cemetery.

The village of Jesmond was mainly woodland and farmland until the nineteenth century when we see an upsurge of fine houses being built by the more affluent members of Newcastle's society. One of these is the Mansion House. In 1886 a local businessman called Sir Arthur Munro Sutherland, who had made his fortune through shipping, bought a property called Thurso House. In 1912 the neighbouring Kelso House became available and Sutherland bought it immediately. He then joined both properties together to create his Mansion House. Sutherland would go on to be the lord mayor of Newcastle, and after his death in 1952 he bequeathed his family home and its large gardens to the people of Newcastle. The City Council has been executor of the Mansion House Trust ever since and still use the building as the official residence of the lord mayor.

The house has had many notable visitors, none more famous than Elizabeth II, who spent the night there in the 1950s. However, it is a different bedroom we are interested in. Situated on the second floor is one bedroom that is known as the 'Ghost Room'. This room received its notorious name after many reports of paranormal activity. Doors on the upstairs corridors are often heard to slam shut when no one is in the area, and there are also reports of footsteps walking up and down the corridor next to the several bedrooms. In the Ghost Room, staff have reported that one of the wardrobe doors fly open with no reasonable explanation. Obviously, they have checked uneven floors and loose locks, but the phenomena cannot be explained. Guests have reported waking up in the middle of the night and being convinced someone is in the room

with them, but when they've switched on the lights, they find they are alone. The door to the room rattles by itself as if someone from outside is trying to get into the room.

Another room of interest is the end bedroom that was once a nursery. Children's voices have been heard coming from the room, as well as the sound of musical toys. There is a window in the room that overlooks the gardens and it is thought that the family's nanny would sit here and watch the children from the window. However, an older woman has been seen at this window from outside. Again, she has been seen when the building is known to be empty.

Finally, the gardens have been known to have adolescent visitors. Children have been heard and seen in the grounds and have been described as wearing Victorian clothing before simply disappearing into the trees.

Jesmond has a fascinating history due to the Dene, and the Mansion House is a fantastic example of the area's grandeur, but who is still visiting the bedrooms of the house? Is it the family of Sir Sutherland who loved their home and don't want to move on, or a previous guest who enjoyed their visit to Newcastle and want to overstay their welcome?

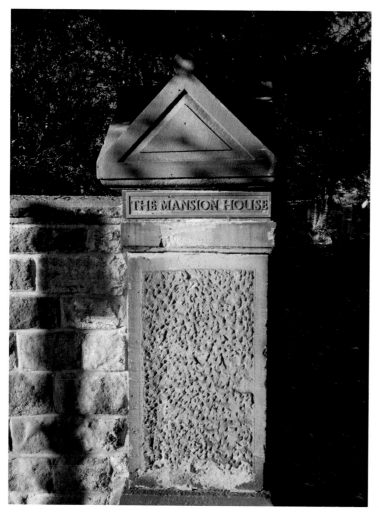

The entrance to Mansion House.

One of the bedrooms that is reported to be haunted by one of the previous owners.

The lobby was the area we heard many bangs around us.

Mansion House.

Where Elizabeth II stayed on her visit to Newcastle.

# Broad Chare

The Broad Chare area of Newcastle's Quayside is home to several buildings of significant historical interest, none more than Trinity House, a series of buildings that were built by a group of seafarers from Newcastle who created the Guild of the Holy Trinity, which would be a charity to take care of their families. Some of these building date back to the sixteenth century.

The entire area is soaked in the history of activity surrounding the Quayside's importance. It is here where you will find the story of Martha Wilson, an important lady who was alive in 1800s but is now one the most famous figures around the alleyways of Broad Chare. Martha Wilson was believed to live in Broad Chare and had become heartbroken after she became a widow. The loneliness was too much and Martha committed suicide in her home. In a very religious city during nineteenth century, suicide was a horrific act of blasphemy and Martha was denied a proper burial. It's said that she was buried at a nearby crossroad with a stake through the heart. This type of burial was commonplace for suicide victims and there are several beliefs as to why these people were buried in this way.

Over the past 200 years since her death, the ghost of Martha has been reported roaming the streets and alleyways around the Broad Chare area. If you are unlucky enough to bump into Martha on a night out or when you are walking along the Quayside be careful. She is described as a wearing a white veil over her face, and as she encourages you to come closer lifts her veil to show a head with no face.

# Newcastle City Hall

During the years I have researched the City Hall, the one thing that has never failed to surprise me is that every Geordie can remember their first concert there. Depending on the generation of the person, I have been told about the performances of huge stars such as The Beatles, Rolling Stones, Cliff Richard, Bon Jovi, Take That and many more. The hall still hosts some top stars and is now home to not only music but many comedians, most of them being household names. So, why would a building full of laughter and applause have many ghost stories attached to it?

The City Hall was opened in 1927 as part of a complex that included the City Baths next door. It would be Newcastle's first purpose-built concert hall and over the next ninety years it would be home to some of music's most famous names. In 1928, an organ was built and is still part of the stage today. The huge instrument, which is still one of the largest in the world, was built by a company called Harrison and Harrison. Unfortunately, today the organ does not work, but it must have been fantastic to hear in the older days of music halls.

The auditorium seats over 2,000 people on the ground floor and surrounding balcony. At the rear of the stage there are three green rooms and a long connecting corridor to the City Baths. The downstairs bar and cloakroom weren't added until the 1970s. The ticket office is quite unique as it stands by itself in a small building on the corner of Vine Street and John Dobson Street and has had its own paranormal activity over the years.

The building stands on the land that was the original Turkish baths, which had been built by local architect John Dobson. The baths were built in 1838, but in 1920 it was decided that it would be cheaper to rebuild the baths than repair the building. Hence the City Pool opened, with the City Hall as part of the development.

Several ghost stories have been shared with me over the years and most revolve around the auditorium including the noise of music being played when the building is empty or hearing the organ music even though we know the organ no longer works. I was also told about a man that walks across the stage when the building is closed but vanishes halfway across.

One of the most interesting reports I was told during an investigation of the building were the voices of children that had been heard on several occasions in the ticket office outside. These voices had also been reported on the long corridor at the rear of the building. I was a little confused as to why the voices of children would be attached to a building that is linked more with adult visitors? And why were these reports only in this area?

As I researched more into the surroundings of the City Hall, I found it is connected to an old school. St Thomas' School stands on Vine Street. Opened in June 1838, the school

would educate some of the local children until 1937 and has been boarded up and closed ever since. The corridor of the City Hall runs alongside what would have been the school playground and the small ticket office was an outbuilding belonging to the school.

None of the stories I was told about this building have been dark or threatening. People have said that they may have been a little scared but never under attack or uncomfortable. Could these be spirits that are returning to an area of their lives that enjoyed and felt happy? Let's hope so.

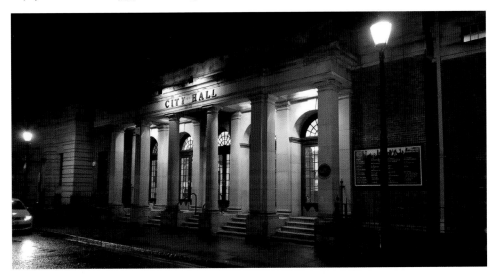

*Above*: City Hall.

*Right:* The back of the hall where there was once a school. Children have been spotted in this area.

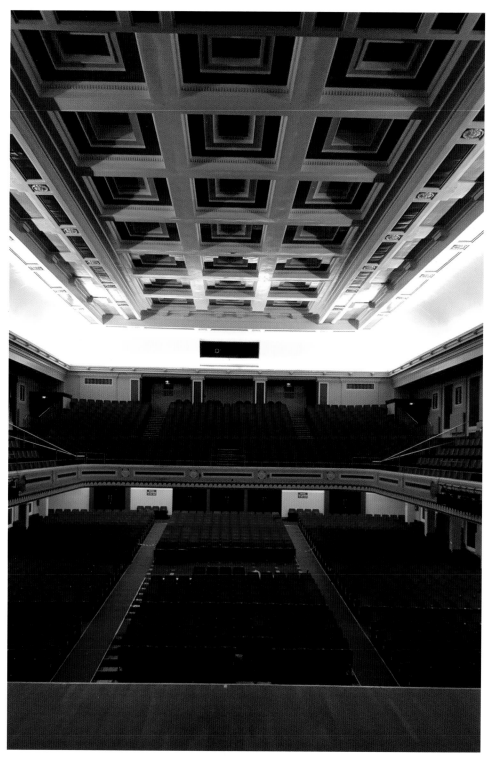

Concert Hall.

# Balmbra's, Bigg Market

The Bigg Market in the centre of Newcastle has a very interesting history. Dating back to the fifteenth century, the Bigg Market is next to the Cloth Market and Groat Market, which would have made the area an extremely important and very busy part the city. Bigg was a type of barley that was very sought after in medieval times and would be the most popular product to buy from the various stalls in the marketplace. Over the centuries the markets would be an important part of the city's economy.

In 1863, a new Town Hall was built in the middle of the market and this building would be home to the Newcastle City Council for over a hundred years, until the council moved to the Civic Centre in 1968.

During the late 1980s and 1990s, the Bigg Market became a party capital. The area became a favourite of partygoers and people would travel from around the world to sample the atmosphere of a night out in 'The Toon'. I can remember the lads queueing outside The Pig & Whistle or Presidents for hours in their t-shirts on a Saturday during a bitter cold north-eastern winter. Or the lasses standing in their little dresses and high heels waiting to get into Vaults or Macey's, with snow falling around them. The one thing you didn't see was a jumper or coat.

Unfortunately, as the millennium changed, so did the drinking habits of the Geordie faithful. The partygoers started to go to the more upmarket Quayside or Osbourne Road in Jesmond, and the Bigg Market and its twenty plus bars started to close. Today most of the buildings are empty and deteriorating as the new generation visit the nearby Diamond Strip, an area made popular by TV show *Geordie Shore*.

Probably the most famous of the pub with the best-known history in the Bigg Market is Balmbra's or, if you are from my generation, Gaslights. During the 1800s the pub was known as the Wheatsheaf and in the late 1840s the ground floor was opened as the Royal Music Saloon. It was a traditional Victorian music hall with singers and dancers visiting to entertain the locals.

In the 1860s the pub was owned by John Balmbra. He converted the ground floor into a much-improved music venue, allowing his business to grow. It's during this period that the Wheatsheaf would enjoy two of its most famous events. In 1862, local singer song writer George Ridley would stand up on the stage and recite his new song, 'The Blaydon Races'. A Geordie anthem was born. I often wonder what George would think if he knew that his song would still be sang with glee at any Geordie gathering over 150 years later.

In 1868 John Balmbra died and the manager, John Handford, who had been running the music hall and pub for the past four years, became the owner. To honour his old friend and business partner he renamed the establishment Balmbra's Music Hall.

Over the following years, Balmbra's was to change ownership and name several times. Then in 1899 tragedy stuck as the building burnt to the ground. It was rebuilt and reopened in 1901 under the name the Charlton Hotel. During 1963 the building was redesigned and opened once again as Balmbra's. The building sadly stands empty today.

For a building so rich with history, it is that I hadn't heard many ghost stories about Balmbra's. No flying glasses or moving chairs. However, one day that was going to change. I was talking to a new acquaintance about the glory days of the Bigg Market. A group of us were discussing which bars we remembered and how long we would queue outside when one of the group told me she used to work in Balmbra's and could tell me some stories about weird goings on that she couldn't explain. Intrigued by what she was saying, I asked her to tell her tales in her own words.

She had worked in Balmbra's for a decade between the eighties and nineties as what she described as a day manager. Her job was to start early and do the various jobs that needed to be done while the bar was shut. She had many admin jobs to complete and the first job of the day would be to go into the back office and count the takings from the night before and get the money ready to go to the bank when it opened.

She had been working there for a couple of years before 'things' started to happen. The first of these things would be when she was sat behind the desk doing her work in the office. She said she was in the middle of counting when there was a knock on the office door. Startled, as she should be the only person in the building, she called out and said 'come in'. No one entered. She then got up and opened the door, but no one was there. Sitting back down, she thought the sound must have been the building settling down or the pipes cooling down.

Moments later there were more knocks on the door. She quickly jumped up and opened it, but again no one was there. She walked through the building but it was empty with all the doors locked.

This activity continued for weeks, the knocking never lasting more than five minutes and would stop as soon as she walked around the building. I asked her if she ever found an explanation for the noise and she replied that she didn't; in fact she had become that used to the knocks that she would shout 'bugger off, I'm trying to work' and the knocking would stop.

The second account involved noises when she was working the rear bar area. She said she would be filling the fridges with bottles ready for the night-time trade and would hear the front door open and someone walk in. The first few times she thought she hadn't locked the door and the cleaners had arrived early only to find nobody was there and the door was locked. After a few months in the job she said she ended up ignoring it and continued to finish her jobs.

The final story she shared with me was probably the most fascinating and the one she was the most hesitant to tell. She said that she had rarely told this story as it still scares her to this day. She was sat in the office having a cup of tea and doing some of her administration work with the office door open when she heard footsteps outside. She looked up the corridor from her seat and saw nobody. Thinking the noises were natural, she continued her work. Moments later she heard the floor creaking and footsteps again. The noises sounded like they were coming from the top of corridor near the bar area but again she could not see anyone. This time she got up and walked to the doorway, but as she looked up the corridor she stopped in her tracks.

In her own words: 'I looked up and saw a dark figure of a man at the end of the corridor. He was tall, easily 6 feet, and was dressed in top hat and tails. For some reason I thought he looked Victorian in dress. I called out to him and told him we were closed. Then he disappeared. Completely vanished.'

My acquaintance then said she searched the entire pub from top to bottom. She went into every room, every toilet, as she was sure someone was in the building. She never found anyone. She told me that this only ever happened once but that was enough.

The last story becomes very interesting when you look at the other pubs in the Bigg Market. A ghost of an Edwardian man has been reported several times in Robinsons Wine Bar, which is only a couple of doors up from Balmbra's. Could this be the same gentleman revisiting his favourite public houses or are the stories a coincidence of two different spectres visiting from the same era?

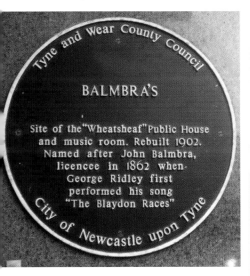

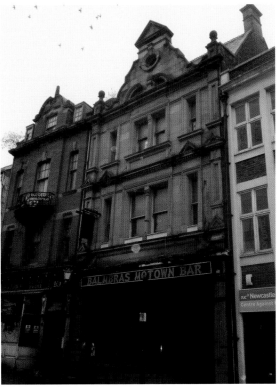

*Above*: Historic plate.

*Right*: Balmbra's.

# St Nicholas' Cathedral

Standing proudly between the Bigg Market and the castle keep is Newcastle's cathedral. A church has stood on this land since 1091, which would have been around the same time as when the castle keep was built. Named St Nicholas', it would have originally been a wooden structure and has been part of the city's story for the past 1,000 years.

The building that we see now was built during the thirteenth century after the building was damaged twice by fires.

The building work continued over the centuries including additional walls and windows, mostly extending the building. The final part to be added to the structure was the tower, which was constructed during the mid-1400s and was designed with a lantern spire that was used to guide ships as they sailed up the Tyne. This could explain the name, as St Nicholas is the patron saint of ships and sailors. The tower is now home to the cathedral's bells, which include 'The Major'. The Major is one of a set of twelve bells that can be heard ringing out around Newcastle. Bequeathed to the cathedral by a local man called Major Anderson, the 6-ton bell was placed in the tower in 1833.

For Newcastle to gain city status, it needed a cathedral and surprisingly it would not achieve this until the nineteenth century.

Originally, St Nicholas' Church applied to be named as a cathedral in 1533, but the original application was to include both Newcastle and Gateshead in the new diocese. The diocese of Durham were not happy with Gateshead's' inclusion and the application was reversed after originally being accepted. Newcastle would stay in the diocese of Durham until 1883 when the diocese of Newcastle was formed, and city status was granted by Queen Victoria.

Understandably, a building with such a vast history has many ghost stories. It is worth noting that when you are walking outside of the building you are walking on a graveyard. The graveyard surrounded the cathedral but is now buried under the paths and roads of the modern city. There have been many reports of ghostly apparitions around the grounds, with figures that disappear when they are approached.

Screams and moaning have been reported inside the cathedral near to the bell tower.

In 1644 during yet another raid of the city by Scotland, the Scots threatened to attack the building and bombard the tower until it was demolished. However, when they were informed the tower was being used as a jail for Scottish prisoners, the army had to back down and couldn't follow through with their threats. The prisoners were left in the tower as a deterrent, but many of them would have died in the squalid conditions through lack of food and poor healthcare. Are the screams

and moans, still heard today, those of the soldiers that were kept in this area of the cathedral?

The final story of the cathedral is possibly the most well known. The spirit of a knight has been reported many times inside. The noise of his armour clanging and his metallic footsteps are often heard first before he appears walking around the building. It is said he walks between the pillars and pews, then disappears around corners. He never speaks or acknowledges anyone and never appears close to people as it always tends to be at the opposite side of the cathedral to where you are standing. No one knows who it is, so he has been named the 'Unknown Knight'.

There is an effigy of a knight in the cathedral that dates to the thirteenth century and is the oldest relic in the building. Again, no one seems to know who it is, but research suggests, by the way he is lying, he would have been involved in the Crusades. Is this a statue in honour of the Unknown Knight? Has he come home to guard his church? If you are in the cathedral and hear his clanking armour maybe you will get an opportunity to ask.

Inside St Nicholas' Cathedral.

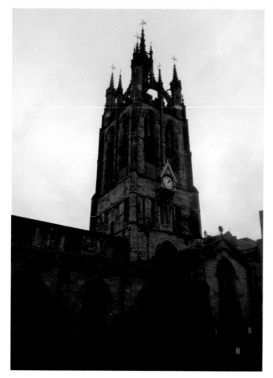

*Above left*: St Nicholas' Cathedral.

*Above right*: St Nicholas' Cathedral.

*Left*: The crypt where ghosts have been seen.

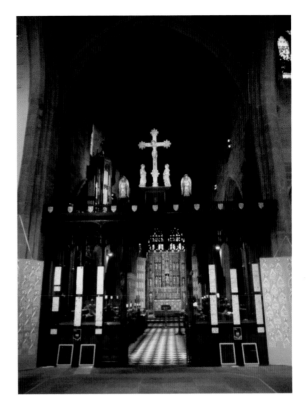

*Right*: The alter.

*Below*: The resting place of an unknown knight that is said to haunt the cathedral.

# Amen Corner

You will find an Amen Corner in the cathedral area of most cities as it is usually the street or area where the priests would finish their prayers after they held a procession around the cathedral ground. Newcastle is no different and you will find their Amen Corner at the edge of the cathedral's graveyard. The corner is also built upon the chambers of the cathedral that still house many tombs.

Reports of ghostly figures wandering around the area are rife and are most common at dusk. People have reported hearing chanting and the smell of incense in the area when there is no one to make the noises or create the smell. Monks have been said to wander Amen Corner, walking through the walls of the buildings or through the fences that surround the graveyard.

You will also find a very strange antiquity in this area. Newcastle's Vampire Rabbit sits over an ornate door looking out on to the city. Little is known of the stone sculpture that depicts a rabbit with fangs and mad eyes. Some say it was put there to defend the graveyard from grave robbers and once had jumped off the door to suck the blood from the criminals' necks. Some say that is simply a gargoyle-type decoration. Whatever the explanation is, it sends a shiver down your back as you walk below it on a cold dark night.

Signpost of
Amen Corner.

Amen Corner.

The graveyard of the cathedral.

*Above left and above right*: The famous Vampire Rabbit overlooking the graveyard.

# The Old Assembly Rooms

Situated on Fenkle Street, the Old Assembly Rooms is one of the finest examples of Georgian architecture you will find in the country. Work was started on the building, designed by William Newton in 1774, after money was raised by the local gentry who wanted to create 'a prestigious venue for elegant recreation'. Two years later, in the summer of 1776, the Assembly Rooms were opened with a grand ball and it started the history of a building that would be recognised for its exceptional levels of service and grandeur, just as its trustees had envisaged.

Over the following century, the Assembly Rooms visitors would read as a who's who of VIPs and royalty. The most notable visitors to the building include Johann Strauss, who played a concert in 1838, and Charles Dickens, who visited in 1852 with his theatrical company. Royal visits include Edward VII and George V, who stayed there during their official visits to Newcastle.

The Assembly Rooms would continue entertaining until the start of the First World War when the building was commissioned by the armed forces. After the war ended the building reopened as the Old Assembly Rooms and Crown Hotel. It continued to operate as a dance hall and was known for its fine dining until it closed in 1967.

The building then stood empty for the following seven years, during which the building started to fall into disrepair. Reading through the old newspapers of the time, you can see residents of Newcastle were afraid of losing the building to the developers who were modernising the city. With the fear of having the building demolished to make way for another soulless concrete tower, the public encouraged the council to intervene and buy the building, but their pleas fell on deaf ears. Fortunately, a buyer was found and in 1974 the Old Assembly Rooms was purchased by Greek brothers Michael and Homer Michaelides.

Rather than demolishing the building and starting again, the brothers spent their time and money refurbishing the hall back to its former glory. The ground floor was opened as the Casino Royale while the upstairs was still used for parties.

For the past forty-five years the Old Assembly Rooms have been operated by the Michaelides family, and it was a sad day when they announced the decision to close at the end of 2019 due to retirement. Let's hope that the building doesn't stay empty for long.

My parents were regulars to the venue in the seventies and eighties, as were most of their friends. Through these people and people they know I have researched the ghost stories surrounding a building better known for fun times.

I think most people in Newcastle know of the Grey Lady. She has been seen around the ballroom and on the balcony several times. The large doors are said to slam shut and lights are reported to flicker and dim in the area. It is said the Grey Lady is the

spirit of a lady from the nineteenth century who was humiliated by her husband in front a group of drunken friends. He had demanded she strip naked and dance around the ballroom. After doing what her husband demanded in fear of the repercussions, she walked up the stairs, onto the balcony, and threw herself over the top. Landing with a thud, she was dead on impact. The appearance of the lady is accompanied by the rustling sounds of a silky gown and quiet sobs.

I was also told about a dark corridor and an office that is always locked due to an angry spirit that would throw things and attack people. The area upstairs was not on the beaten track of the public areas and was described to me as a foreboding corridor. Although the corridor was well lit, the area always felt that it was in shadows. Both men and women would return from the area in tears for reasons they could not explain, although most women had said they had become so scared they had started to shake and the room around felt like it was getting darker and darker. It is believed that the office was locked and unused after a series of events when staff had been left terrified as items were hurled at them and some reports of them being attacked by an unseen source. Although I have never had these stories verified, the stories kept coming about the office that people would not enter alone.

Who or what is still visiting the Old Assembly Rooms? Is it a disgruntled guest that cannot let go? Is it someone involved with the Grey Lady and their guilt won't let them cross over? Or is it something not connected to the building at all? Could it be someone connected to the land as it was built on part of the cathedral gardens?

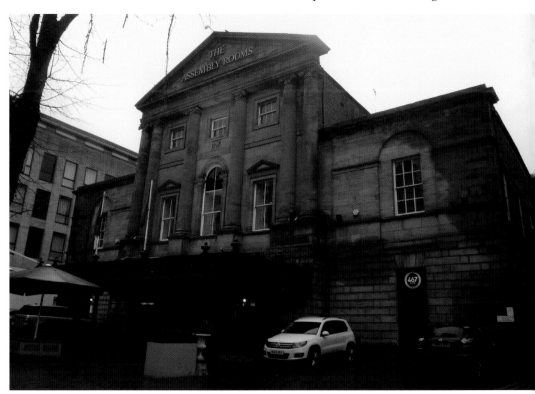

The Old Assembly Rooms.

Window where a ghostly woman is seen.

# All Saints Church

At the bottom of Pilgrim Street and perched overlooking the Quayside you will find All Saints Church and its surrounding graveyard. There has been an All Saints Church on this site since 1286. Over the following 500 years the church doesn't appear in the history books other than to mention its repairs or expansion.

In 1786 it was decided to demolish the original building as the years had taken their toll and it would cost more to repair the church than build a new one. The building work started, and it would take ten years to complete the magnificent Gothic-designed All Saints Church we see now. It continued to serve its parishioners until 1961, only needing some restoration work in the 1880s, which included an improved graveyard.

The church was deconsecrated and during the end of the twentieth century it was used by many community projects. Due to storm damage the building was closed in 2010 as the roof had become unsafe and this beautiful building was left to fall into ruin. In 2019 the sound of worship would be heard again as the Evangelical Presbyterian Church of England and Wales completed a huge restoration project and reopened the doors for people to enjoy the wonders of All Saints Church.

One of the ghost stories of the church is that of the ghost of Captain William Hedley. His spirit is always spotted on the western side of the church. The captain died during a horrific accident during the demolishing of the original church. He was observing the work when stones from the west door fell on him, crushing him under tons of rubble. He died instantly. It is reported that his ghost walks around the church whenever there is construction or restoration work being done in the building.

The graveyard is also full of stories of ghostly noises and apparitions. Tales of white figures disappearing behind tombstones or figures standing on top of graves abound. However, All Saints Church has a resident ghost and his story is in the history books for all to see and has the name of 'Jack the Beadle'.

In Victorian times a beadle was a church policeman. Paid by the church, their job was to keep the church and graveyard safe from unwanted visitors. The country was in the middle of the heinous crime of grave robbing, where criminals were digging up dead bodies and selling them to local doctors for experimental medicine. A beadle was a well-respected role and would be a man that was well thought of by the community.

In 1858, after reports of a lot of night-time activity in the graveyard, the beadle of All Saints was caught stealing from coffins. At first the authorities thought he was involved with grave robbers but in fact he was robbing from the coffins. He would dig up the newly buried coffins and remove any brass or lead from the caskets and sell it to local scrap merchants, giving him a very healthy income.

Jack would be found guilty and sent to jail for eighteenth months. However, his punishment did not stop there. He has been spotted on many occasions (there is

footage on a potential sighting on YouTube) roaming the graveyard of the church, never being able to leave as penance for his unholy crimes. So, if you are walking by in the evening and see a light moving around in the darkness, go closer and you might get a glimpse of Jack the Beadle.

Inside the church.

The Gothic spire.

All Saints Church.

*Above and right*: Home of the
ghost of Jack the Beadle.

# The Hancock Museum

I am going to finish this book of the paranormal with the very first ghost story I can remember being told about Newcastle. I would have been about eight or nine and I was going on a school trip to the Hancock Museum when I was told to watch out for the Newcastle Mummy. The Hancock Museum is at the north entrance to Newcastle and is located next to Newcastle University and Exhibition Park.

The Victorian building was opened in 1884 and was called the New Museum for Natural History. A local ornithologist called John Hancock had been fundamental in raising the funds to open the museum, so in 1890, when he died, it seemed apt to rename the building after him. The Hancock Museum was born.

The Hancock Museum.

It became renowned for its collection of birds, animals, plants and flowers. However, one of its most famous attractions was its Egyptian mummies. The first of the mummies had originally arrived in Newcastle in 1821 and she was on display at the Lit & Phil on Westgate Road, with the second mummy being added to the collection in 1825. These were bought by the Natural History Society and transported to the Hancock Museum, where they have lived ever since. We know now that the mummies date back over 3,000 years and came from the Luxor region of Egypt. In 2009, the Hancock Museum was refurbished, expanded and renamed the Great North Museum: Hancock and is still home of the 'Geordie Mummies'.

If you visit the museum and are looking at the mummies, be very observant, as sometimes it's said that the mummies eyes move as they look straight back at you. It is also said that late at night the mummies rise from their caskets and walk around looking at any new exhibits. You can hear them moaning and shuffling around in the dark, taking in their surroundings and looking for a way home. If they are disturbed, they simply return to their caskets until the next night.

I don't know how true the story is or whether it is just a spooky tale handed down through the generations, as I must admit to terrifying my sons when they were younger with the story of the mummies that still wander around the old Hancock Museum.

# Conclusion

Well, that's it folks. I hope you have enjoyed the book and the many ghost stories surrounding Newcastle. I hope you have enjoyed delving into the history of the streets, alleyways and buildings that make this city so fascinating.

As a ghosthunter I am often asked where is my favourite location? I am honest when I say that I have been fortunate to visit some of the most fabulous places across the country and cannot pick one individual location. However, taking away the paranormal element, my favourite place to visit is the Tyne Bridge.

When standing on the Tyne Bridge, you can look up and down a river that has provided for generations of Geordies. It has supplied food, drink, employment and riches for thousands of years to the many generations of families that have lived on its banks. You can look up the Tyne and easily use your mind's eye to relive the Roman invasion, with the legions marching up to the hill to create a northern powerhouse as they built their first fort. Then, in a blink of an eye, you are transported to the Dark Ages as you gaze upon the castle keep or the top of the cathedral.

Moving around you can see medieval Newcastle as you look upon the old buildings of the Quayside, then instantly jump forward in time and look at the beauty of Victorian Britain with views of Richard Grainger's Grey Street. Finally, you can see today's additions that are currently being constructed, such as office blocks and hotels, growing the city upwards and changing Newcastle's skyline forever.

As we spend much of our life with our heads down as we walk around in a hurry or we are texting away on our phones and devices, I ask you to stop for a moment, take a few minutes to slow down and look up. Enjoy the architecture, enjoy the history of the buildings that surround you, and think of the people who helped create our built environment. Look into the windows and doorways because you'll never know who or what you will see.

At the start of the book I wrote 'I love Newcastle'. I now hope you do too!